The Foodspotting Field Guide

Edited by April V. Walters

CHRONICLE BOOKS

SAN FRANCISCO

ISBN: 978-1-4521-1987-8

Manufactured in China

Designed by Alice Chau
Text by April V. Walters
Photography courtesy of Foodspotting, LLC,
in accordance with Terms of Service.

Front cover (left to right): Khanom Krok (spotted by Nutoey), Bibimbap (spotted by Emily Ng), Churros con Chocolate (spotted by Johnny Ferio)

Back cover (left to right): Shakshouka (spotted by Pinrat), Cacio e Pepe (spotted by Tantissimo), Momo (spotted by Kamol Chinupagarnbong), Börek (spotted by Meem)

10 9 8 7 6 5 4 3 2 1

Chronicle Books, LLC
680 Second Street
San Francisco, California 94107
www.chroniclebooks.com

Dedicated to Foodspotters around the world

Preface

Dear Foodspotter,

Have you ever heard of *tteokbokki* (Korean rice sticks in red sauce)? *Kunafa* (an Arabic cheese-filled shredded wheat–like pastry)? Or bubble and squeak (a British patty made of leftover potatoes and cabbage)? Growing up in Pittsburgh, Pennsylvania, I knew my meat and potatoes well. And while childhood favorites like pierogies and schnitzel will always have a place in my heart, a few trips during the past few years have opened my eyes to a world of dishes I never knew existed.

A few months after a particular trip to Japan that introduced me to the Osaka-born dishes *takoyaki* (literally "fried octopus") and *okonomiyaki* (which are savory pancakes), I woke up with the idea to create a field guide to food—a visual guide to dishes you should know about. Given the growing interest in food that I observed among friends and family, I wanted to introduce people to some of the dishes I'd discovered over the past few years and encourage people to track them down and try them locally. It was to be like a bird guide or passport, only for food!

But when I realized there was no easy way to search for specific dishes nearby, I got sidetracked: The book idea evolved into an app idea, and the Foodspotting website and mobile apps were born. I teamed up with my cofounders, Ted Grubb and Soraya Darabi, and in January 2010, we launched the first app for finding and sharing great dishes, not just restaurants. Three years later, Foodspotters had contributed more

than 3 million photos of dishes from around the world—from our childhood hometowns in Pennsylvania to food capitals like Tokyo and Istanbul—and the time seemed ripe to create this book.

While cataloging every dish in the world is a task better suited to the infinite canvas of the Web, we did our best to select a few of our team's favorite dishes from a diversity of countries and regions and illustrated them with real photos from Foodspotting members, taken in the country of origin wherever possible. Start your Foodspotting journey by turning this page to discover "The Foodspotting 75." This interactive checklist includes all 75 dishes paired with the region with which they are most closely associated. Locate the dish you want to try and turn to the corresponding entry, where you'll find descriptions of the dish's history and origins, plus common identifying features so you'll know what to look for at restaurants and food stands. The fill-in sections are where you can record details of your encounters with each dish, like where and when you sampled it and what you thought of it. We hope that this field guide will equip you to try these and other new dishes for yourself and keep track of your own unique experiences.

We look forward to seeing what you spot!

Alexa Andrzejewski
Cofounder of Foodspotting
with April V. Walters, editor and foodspotter
www.foodspotting.com

The Foodspotting 75

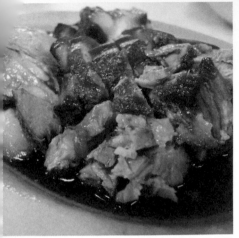

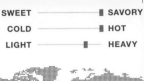

SWEET ———————— ■ SAVORY
COLD ———————— ■ HOT
LIGHT ———————— ■ ———— HEAVY

ORIGIN: Philippines

TYPICAL INGREDIENTS:
Chicken, vinegar, garlic,
soy sauce, bay leaves

1 / MEAL

Adobo

/ah-DOH-boh/ Peanut butter and jelly, ketchup and fries, vinegar and
garlic—some flavors just belong together. In this quintessential Filipino
dish, vinegar and garlic make a marinade with bay leaves, pepper, and soy
sauce. Meat, typically chicken or pork, slowly simmers in the marinade
until it is fall-off-the-bone tender, and then it's served over white rice.
Vegetables can also be cooked this way. Adobo flakes feature leftover
adobo meat that has been shredded and pan-fried. Spanish explorers
encountered this dish in the Philippines a long time ago and applied their
name for "marinade" to it. Adobo variants can also be found in Peru and
Puerto Rico.

I spotted this

ON:

AT:

WITH:

WANT

TRIED

LOVED

My thoughts

TASTES LIKE:

☆☆☆☆☆
FLAVOR

FEELS LIKE:

☆☆☆☆☆
TEXTURE

SMELLS LIKE:

☆☆☆☆☆
AROMA

LOOKS LIKE:

☆☆☆☆☆
APPEARANCE

SOUNDS LIKE:

☆☆☆☆☆
NOISE

ADDITIONAL NOTES:

HOW IT MADE ME FEEL

♡♡♡♡♡
OVERALL

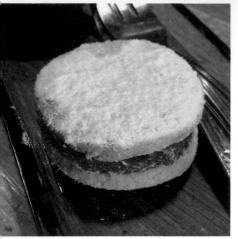

SWEET ▮—————— SAVORY
COLD —————▮—— HOT
LIGHT ———▮———— HEAVY

ORIGIN: Spain, but considered Argentinean

TYPICAL INGREDIENTS: Cookies, dulce de leche, powdered sugar or coconut

SPOTTED BY BABARIZAL

2 / DESSERT

Alfajor

/al-fah-HOAR/ Originally from Spain, the enormously popular Argentine alfajor features a thick layer of *dulce de leche*—caramelized sweet milk— sandwiched between two shortbread-like cookies. There are a multitude of variations: some may be coated on one end in powdered sugar, while others feature the edges of the dulce de leche filling rolled in coconut. The Spanish version is round like a cigar, rolled in powdered sugar, and made with honey, nuts, and spices. Nibble carefully as you enjoy an alfajor, for it is light and delicate. You'll likely have to dust crumbs off your shirt after you've enjoyed one—but you'll agree they're worth the mess!

I spotted this

ON:

AT:

WITH:

WANT

TRIED

LOVED

My thoughts

TASTES LIKE:

☆☆☆☆☆
FLAVOR

FEELS LIKE:

☆☆☆☆☆
TEXTURE

SMELLS LIKE:

☆☆☆☆☆
AROMA

LOOKS LIKE:

☆☆☆☆☆
APPEARANCE

SOUNDS LIKE:

☆☆☆☆☆
NOISE

ADDITIONAL NOTES:

HOW IT MADE ME FEEL

♡♡♡♡♡
OVERALL

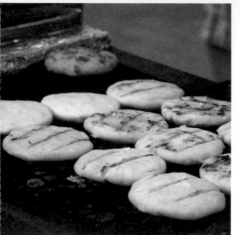

SWEET	──────── ■	SAVORY
COLD	──────── ■──	HOT
LIGHT	──────── ■──	HEAVY

ORIGIN: Venezuela

TYPICAL INGREDIENTS:
Cornmeal or wheat dough,
fillings

SPOTTED BY JOANNA RIQUETT

3 / SNACK

Arepas

/ah-RAY-pahs/ This round South American bread is served split open and
stuffed, making for an often unmanageable sandwich. Venezuelan arepas
are served at night. They may be small or large, but are thick enough to
have both a crisp outside and soft inside. Served with savory fillings such
as cheese, vegetables, meat, and sauce, just one arepa will satisfy your
need for a salty, fried snack. Colombian arepas are eaten during the day
and feature bread that is thicker than a tortilla. They might be served
plain or with fillings such as scrambled eggs, butter, and cheese.

I spotted this

ON:

AT:

WITH:

WANT

TRIED

LOVED

My thoughts

TASTES LIKE:

☆ ☆ ☆ ☆ ☆

FLAVOR

FEELS LIKE:

☆ ☆ ☆ ☆ ☆

TEXTURE

SMELLS LIKE:

☆ ☆ ☆ ☆ ☆

AROMA

LOOKS LIKE:

☆ ☆ ☆ ☆ ☆

APPEARANCE

SOUNDS LIKE:

☆ ☆ ☆ ☆ ☆

NOISE

ADDITIONAL NOTES:

HOW IT MADE ME FEEL

♡ ♡ ♡ ♡ ♡

OVERALL

SWEET	—■———	SAVORY
COLD	———■—	HOT
LIGHT	—■———	HEAVY

ORIGIN: Poland

TYPICAL INGREDIENTS: Yeast dough with dried fruits and nuts, with additions of chocolate or rum

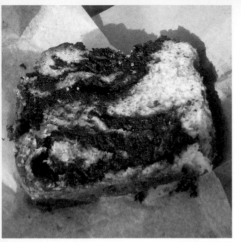

SPOTTED BY BK

4 / DESSERT

Baba

/BAH-bah/ Originally created in the area of present-day Poland and Russia, yeasted baba cakes have transformed over the decades; they are said to be a variation of the German *kugelhopf* cake. The modern recipe is made from a yeasted dough rich in eggs and butter. Sometimes babas are made in small ring molds, soaked with a rum-spiked sugar syrup, and called *baba au rhum*. One baba variation is named *babka*. It is a Jewish cake featuring bread that is flaky and layered with thick bands of chocolate. A similar cake in Turkey is known as "father's cake," while a larger French version without dried fruit is called a *savarin*.

I spotted this

ON:

AT:

WITH:

WANT

TRIED

LOVED

My thoughts

TASTES LIKE:

☆ ☆ ☆ ☆ ☆

FLAVOR

FEELS LIKE:

☆ ☆ ☆ ☆ ☆

TEXTURE

SMELLS LIKE:

☆ ☆ ☆ ☆ ☆

AROMA

LOOKS LIKE:

☆ ☆ ☆ ☆ ☆

APPEARANCE

SOUNDS LIKE:

☆ ☆ ☆ ☆ ☆

NOISE

ADDITIONAL NOTES:

HOW IT MADE ME FEEL

♡ ♡ ♡ ♡ ♡

OVERALL

SWEET	——————■——	SAVORY
COLD	—■————————	HOT
LIGHT	———■——————	HEAVY

ORIGIN: Vietnam

TYPICAL INGREDIENTS:
Baguette, roast meat, pâté,
pickled carrots and daikon,
jalapeño slices, cilantro

SPOTTED BY S.C.H.N.E.E.

5 / MEAL

Bánh Mì

/BAHN mee/ The French colonists introduced Vietnam to baguettes and
pâté, but thank the locals for the addictive mix of meat and pickled veg-
gies. These zesty, inexpensive sandwiches contain meat or tofu, pickled
vegetables, sliced jalapeño, and fresh cilantro. *Bánh mì* also indicates just
the fluffy loaves of bread in Vietnamese; for the fully loaded sandwich,
ask for *bánh mì thit* or the vegetarian version, *bánh mì chay*. In Vietnam,
it's often sold from carts or bánh mì shops, while in the United States, you
can find it on restaurant menus.

spotted this

ON:

AT:

WITH:

WANT

TRIED

LOVED

My thoughts

TASTES LIKE:

☆☆☆☆☆
FLAVOR

FEELS LIKE:

☆☆☆☆☆
TEXTURE

SMELLS LIKE:

☆☆☆☆☆
AROMA

LOOKS LIKE:

☆☆☆☆☆
APPEARANCE

SOUNDS LIKE:

☆☆☆☆☆
NOISE

ADDITIONAL NOTES:

HOW IT MADE ME FEEL

♡♡♡♡♡
OVERALL

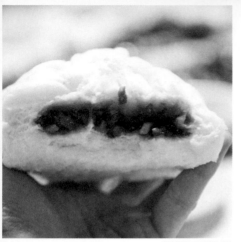

SWEET ——————■——— SAVORY
COLD ————————■— HOT
LIGHT ————————■—— HEAVY

ORIGIN: China

TYPICAL INGREDIENTS: Flour, yeast, sugar, sweet and savory fillings

SPOTTED BY VERLISIA

6 / SNACK

Baozi

/BAU-za/ Baozi, or *bao* for short, are bread-like buns made from wheat flour, which are filled and steamed or baked. The steamed versions are identifiable by their puckered, pinched tops and springy texture. In China, they are often eaten for breakfast, while elsewhere they are part of a dim sum meal or an on-the-go snack. The most notable bao is *char siu bao*, which is filled with minced pork in a sweet barbeque sauce. Another version is the chicken-filled *gao bao jai*. A multitude of varieties exist, including those filled with lotus paste, sweet bean paste, and custard. Similar filled buns in other Asian cultures include Nepalese *momo*, Japanese *nikuman*, Korean *wang mandu*, and Filipino *siopao*.

I spotted this

ON:

AT:

WITH:

WANT

TRIED

LOVED

My thoughts

TASTES LIKE:

☆☆☆☆☆
FLAVOR

FEELS LIKE:

☆☆☆☆☆
TEXTURE

SMELLS LIKE:

☆☆☆☆☆
AROMA

LOOKS LIKE:

☆☆☆☆☆
APPEARANCE

SOUNDS LIKE:

☆☆☆☆☆
NOISE

ADDITIONAL NOTES:

HOW IT MADE ME FEEL

♡♡♡♡♡
OVERALL

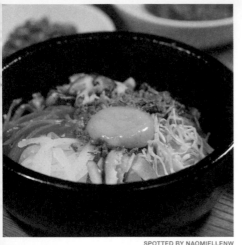

SWEET	▇	SAVORY
COLD	▇	HOT
LIGHT	▇	HEAVY

ORIGIN: Korea

TYPICAL INGREDIENTS: Rice, vegetables, meat, egg

SPOTTED BY NAOMIELLENW

Bibimbap

/bee-bim-BOP/ Bibimbap means "mixed rice" in Korean. It's a straight-forward and delicious dish of rice, vegetables, meat, and egg that may have originated from the tradition of mixing food offerings at ancestral altars. Once you're served, carefully use a spoon or chopsticks to combine layered ingredients like julienned cucumber and zucchini, spinach, soybean sprouts, kimchi, *gochujang* (chili sauce), and meat or seafood, incorporating the raw egg cracked on top. A not-to-be-missed version of bibimbap is *dolsot bibimbap*, which is served in a scorching-hot stone pot that crisps the rice at the edges.

I spotted this

ON:

AT:

WITH:

WANT

TRIED

LOVED

My thoughts

TASTES LIKE:

☆ ☆ ☆ ☆ ☆
FLAVOR

FEELS LIKE:

☆ ☆ ☆ ☆ ☆
TEXTURE

SMELLS LIKE:

☆ ☆ ☆ ☆ ☆
AROMA

LOOKS LIKE:

☆ ☆ ☆ ☆ ☆
APPEARANCE

SOUNDS LIKE:

☆ ☆ ☆ ☆ ☆
NOISE

ADDITIONAL NOTES:

HOW IT MADE ME FEEL

♡ ♡ ♡ ♡ ♡
OVERALL

SWEET	———————	■ SAVORY
COLD	———■———	HOT
LIGHT	—■———————	HEAVY

ORIGIN: France

TYPICAL INGREDIENTS: Bone marrow, toast

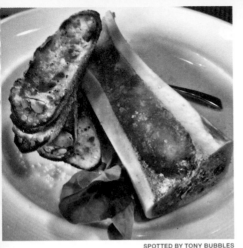

SPOTTED BY TONY BUBBLES

8 / SIDE

Bone Marrow

/BONE mare-roh/ Simply prepared or as part of a fancy meal, soft, cooked bone marrow challenges the diner to scrape and sop up every last bit of salty, juicy interior. Found primarily in leg bones, it is intensely meat-flavored, but spreads on crusty bread like gooey, melted fat. The marrow is sometimes presented in bones split lengthwise or with a small, thin marrow spoon to scoop it out of whole bones. Marrow is also a feature of the Italian dish *osso buco* and is sometimes added to soups.

I spotted this

ON:

AT:

WITH:

WANT

TRIED

LOVED

My thoughts

TASTES LIKE:

☆ ☆ ☆ ☆ ☆
FLAVOR

FEELS LIKE:

☆ ☆ ☆ ☆ ☆
TEXTURE

SMELLS LIKE:

☆ ☆ ☆ ☆ ☆
AROMA

LOOKS LIKE:

☆ ☆ ☆ ☆ ☆
APPEARANCE

SOUNDS LIKE:

☆ ☆ ☆ ☆ ☆
NOISE

ADDITIONAL NOTES:

HOW IT MADE ME FEEL

♡ ♡ ♡ ♡ ♡
OVERALL

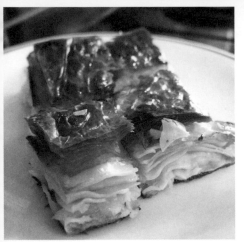

SWEET ▪ SAVORY
COLD ▪ HOT
LIGHT ▪ HEAVY

ORIGIN: Turkey

TYPICAL INGREDIENTS: Flaky pastry, fillings

9 / SNACK

Börek

/BUR-rick/ *Börek* or *böreği* is the Turkish name for a multitude of flaky, filled pastries found in many cuisines. They might be served like a layer cake cut into pieces or as individual cigar shapes or half-moon pies. Börek were popular as far back as the Ottoman Empire. They are made with layers of phyllo-like pastry, with sweet fillings such as custard or savory fillings such as feta, minced meat, potatoes, and other vegetables. Börek can be fried or baked. Cultural variations include Arabian *burek*, Albanian *byrek*, Greek *bouréki*, and Israeli *bourekas*.

I spotted this

ON:

AT:

WITH:

WANT

TRIED

LOVED

My thoughts

TASTES LIKE:

☆☆☆☆☆
FLAVOR

FEELS LIKE:

☆☆☆☆☆
TEXTURE

SMELLS LIKE:

☆☆☆☆☆
AROMA

LOOKS LIKE:

☆☆☆☆☆
APPEARANCE

SOUNDS LIKE:

☆☆☆☆☆
NOISE

ADDITIONAL NOTES:

HOW IT MADE ME FEEL

♡♡♡♡♡
OVERALL

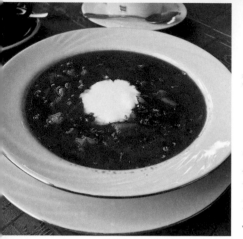

SWEET	▬	SAVORY
COLD	▬	HOT
LIGHT	▬	HEAVY

ORIGIN: Ukraine

TYPICAL INGREDIENTS: Stock, beets and beet greens, potatoes

SPOTTED BY ALEXANDER POKATASHKIN

Borscht

/BORESHT/ Borscht is originally from Ukraine, but the name comes from the Yiddish language. It doesn't need many ingredients, just beef or pork broth and beets. The resulting soup is a stunning dark red except when sour cream or yogurt is added; then it turns light pink. You might also find garnishes of raw cucumber, dill, diced vegetables, or hard-boiled egg—especially in the cold version. While this soup can be made with chunks of potato or carrots, it is sometimes puréed smooth and served hot with rye bread. There are also varieties of borscht with tomato as the base, or sorrel for a green version of the soup.

spotted this

ON:

AT:

WITH:

WANT

TRIED

LOVED

My thoughts

TASTES LIKE:

☆☆☆☆☆
FLAVOR

FEELS LIKE:

☆☆☆☆☆
TEXTURE

SMELLS LIKE:

☆☆☆☆☆
AROMA

LOOKS LIKE:

☆☆☆☆☆
APPEARANCE

SOUNDS LIKE:

☆☆☆☆☆
NOISE

ADDITIONAL NOTES:

HOW IT MADE ME FEEL

♡♡♡♡♡
OVERALL

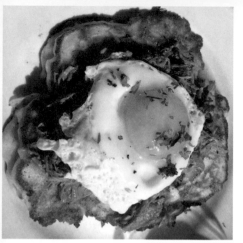

SWEET ———— ■ SAVORY

COLD ———— ■ ———— HOT

LIGHT ———— ■ HEAVY

ORIGIN: Ireland

TYPICAL INGREDIENTS: Grated potatoes, mashed potatoes, flour, buttermilk

SPOTTED BY TARA ERNSKE

11 / SIDE

Boxty

/BOX-tee/ Boxty comes from the Gaelic *bacstaí* or *arán bocht tí*, meaning "poor-house bread." Raw grated potatoes are blended with mashed potatoes, flour, buttermilk, and, sometimes, egg. It can be cooked into either a loaf (called *potato bread*) or a thick smooth pancake (called *boxty* and sometimes *poundy*). As a loaf, it's sliced, toasted, and served with meat. It can also be cooked as a thin crêpe-like round, either stuffed or used as a wrapper. Boxty is often served alongside a full Irish breakfast of eggs, bacon, sausage, black pudding, toast, and tomato slices. The Jewish latke, the English hash brown, the Polish *placki ziemniaczane*, and German *kartoffelpuffer* are similar but have a coarser potato texture.

spotted this

ON:

AT:

WITH:

WANT

TRIED

LOVED

My thoughts

TASTES LIKE:

☆ ☆ ☆ ☆ ☆
FLAVOR

FEELS LIKE:

☆ ☆ ☆ ☆ ☆
TEXTURE

SMELLS LIKE:

☆ ☆ ☆ ☆ ☆
AROMA

LOOKS LIKE:

☆ ☆ ☆ ☆ ☆
APPEARANCE

SOUNDS LIKE:

☆ ☆ ☆ ☆ ☆
NOISE

ADDITIONAL NOTES:

HOW IT MADE ME FEEL

♡ ♡ ♡ ♡ ♡
OVERALL

SWEET ——————— ■ SAVORY

COLD ———— ■ HOT

LIGHT ——————— ■ HEAVY

ORIGIN: United Kingdom

TYPICAL INGREDIENTS:
Potatoes, cabbage, onion,
brown gravy

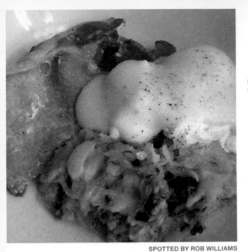

SPOTTED BY ROB WILLIAMS

12 / SIDE

Bubble and Squeak

/BUH-bull and SKWEEK/ The basic idea behind bubble and squeak is the same for both homemade recipes and the kind you'd order at a British pub. It features roughly chopped cooked root veggies and cabbage—traditionally leftovers from a roast—formed into patties and pan-fried. The name comes from the sound it makes while cooking. Brits consider bubble and squeak to be comfort food, and it has gained a following in the United States. It is often served with cold meat, pickles, and brown sauce, or with an English breakfast of fried eggs and meat.

spotted this

ON:

AT:

WITH:

WANT

TRIED

LOVED

My thoughts

TASTES LIKE:

☆ ☆ ☆ ☆ ☆
FLAVOR

FEELS LIKE:

☆ ☆ ☆ ☆ ☆
TEXTURE

SMELLS LIKE:

☆ ☆ ☆ ☆ ☆
AROMA

LOOKS LIKE:

☆ ☆ ☆ ☆ ☆
APPEARANCE

SOUNDS LIKE:

☆ ☆ ☆ ☆ ☆
NOISE

ADDITIONAL NOTES:

HOW IT MADE ME FEEL

♡ ♡ ♡ ♡ ♡
OVERALL

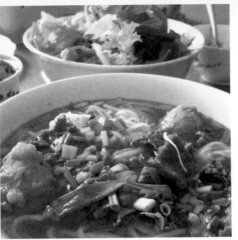

SWEET	━━━━■	SAVORY
COLD	━━━━■	HOT
LIGHT	━━━■━	HEAVY

ORIGIN: Vietnam

TYPICAL INGREDIENTS: Beef, beef broth, rice noodles, lemongrass

SPOTTED BY GLOBALTINE

13 / MEAL
Bún bò Huế

/boon bah HOY/ Similar to Vietnamese *phở*, *bún bò* is a soup made with rice noodles and beef broth. However, *bún bò Huế* relies heavily on lemongrass, which serves as a sharp contrast to the meatiness, sweetness, and spiciness of the broth. Bún bò usually contains cooked beef shank, spices, ginger, fish or shrimp sauce, sugar, and chili oil. You might also find versions with oxtail, pig knuckle, and cubes of congealed pork blood. Dress up the soup with lime wedges, cilantro (traditionally *rau ram*), mint, basil, onions, cabbage, bean sprouts, and sawtooth herb before eating.

I spotted this

ON:

AT:

WITH:

WANT

TRIED

LOVED

My thoughts

TASTES LIKE:

☆ ☆ ☆ ☆ ☆

FLAVOR

FEELS LIKE:

☆ ☆ ☆ ☆ ☆

TEXTURE

SMELLS LIKE:

☆ ☆ ☆ ☆ ☆

AROMA

LOOKS LIKE:

☆ ☆ ☆ ☆ ☆

APPEARANCE

SOUNDS LIKE:

☆ ☆ ☆ ☆ ☆

NOISE

ADDITIONAL NOTES:

HOW IT MADE ME FEEL

♡ ♡ ♡ ♡ ♡

OVERALL

SWEET	——————— ▉ SAVORY
COLD	——— ▉ —— HOT
LIGHT	——— ▉ —— HEAVY

ORIGIN: Italy

TYPICAL INGREDIENTS: Pasta, pepper, cheese

SPOTTED BY TANTISSIMO

Cacio e Pepe

/cah-CHO ay PEP-pay/ This classic Roman dish of pasta, cheese, and pepper relies on high-quality ingredients for its surprising complexity. First, butter or olive oil and freshly cracked pepper bond into a nutty, spicy slick over heat. Then the humble pasta water is used to blend and create the sauce base. Cheese, usually a bold Pecorino Romano, melts into and thickens the liquid. The sauce is typically tossed with a long pasta like *bucatini* (long tubular pasta, a sauce-catcher), spaghetti, egg tagliolini, or thin angel hair. You'll swear that the flavors couldn't have come from such simple ingredients.

I spotted this

ON:

AT:

WITH:

WANT

TRIED

LOVED

My thoughts

TASTES LIKE:

☆☆☆☆☆
FLAVOR

FEELS LIKE:

☆☆☆☆☆
TEXTURE

SMELLS LIKE:

☆☆☆☆☆
AROMA

LOOKS LIKE:

☆☆☆☆☆
APPEARANCE

SOUNDS LIKE:

☆☆☆☆☆
NOISE

ADDITIONAL NOTES:

HOW IT MADE ME FEEL

♡♡♡♡♡
OVERALL

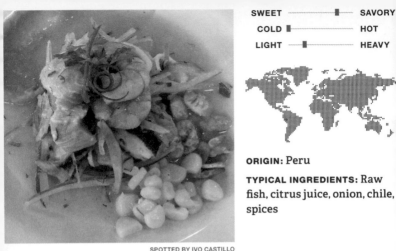

SWEET ————————■——— SAVORY
COLD ■———————————— HOT
LIGHT ———■——————— HEAVY

ORIGIN: Peru

TYPICAL INGREDIENTS: Raw fish, citrus juice, onion, chile, spices

SPOTTED BY IVO CASTILLO

15 / SIDE

Ceviche

/seh-BEE-chay/ This refreshing dish includes bite-size chunks of sushi-grade raw fish marinated in fresh lemon or lime juice, onion, chile bits, and spices. The citrus juice alters the meat proteins in a way similar to cooking with heat. Look for ceviche as an appetizer in fish-loving Peru and across Central and South America. Notice any bitterness in the marinade; that comes from over-squeezing the lemons or limes during preparation. In Mexico, you'll find shrimp, avocado, cilantro, and some tomato in the mix. Pour the citrusy marinade into a glass and try a *leche de tigre* (tiger's milk shooter).

I spotted this

ON:

AT:

WITH:

WANT

TRIED

LOVED

My thoughts

TASTES LIKE:

☆☆☆☆☆
FLAVOR

FEELS LIKE:

☆☆☆☆☆
TEXTURE

SMELLS LIKE:

☆☆☆☆☆
AROMA

LOOKS LIKE:

☆☆☆☆☆
APPEARANCE

SOUNDS LIKE:

☆☆☆☆☆
NOISE

ADDITIONAL NOTES:

HOW IT MADE ME FEEL

♡♡♡♡♡
OVERALL

SWEET ▬▬▬▬▬▬ ■ SAVORY

COLD ▬▬▬ ■ ▬▬ HOT

LIGHT ▬▬▬▬▬▬ ■ HEAVY

ORIGIN: Singapore

TYPICAL INGREDIENTS: Rice noodles, rice cake strips, bean sprouts, shrimp, egg, pork fat

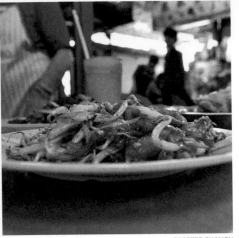

SPOTTED BY M4SH

Char Kway Teow

/char kway TEE-ow/ For true fans, the only place to get an authentic plate of char kway teow is from a hawker (street food) stall in Singapore, Indonesia, or Malaysia. However, it's also popular throughout Australia, New Zealand, and Brunei. Literally "stir-fried rice cake strips," char kway teow contains flat rice noodles stir-fried over very high heat with pork fat, bean sprouts, shrimp paste, soy sauce, chile, shrimp, chives, and egg. Originally made fast and hot for laborers, char kway teow might also include cockles, fish cake, and Chinese sausage. The Thai dish *pad see ew* is similar.

spotted this

ON:

AT:

WITH:

WANT

TRIED

LOVED

My thoughts

TASTES LIKE:

☆ ☆ ☆ ☆ ☆
FLAVOR

FEELS LIKE:

☆ ☆ ☆ ☆ ☆
TEXTURE

SMELLS LIKE:

☆ ☆ ☆ ☆ ☆
AROMA

LOOKS LIKE:

☆ ☆ ☆ ☆ ☆
APPEARANCE

SOUNDS LIKE:

☆ ☆ ☆ ☆ ☆
NOISE

ADDITIONAL NOTES:

HOW IT MADE ME FEEL

♡ ♡ ♡ ♡ ♡
OVERALL

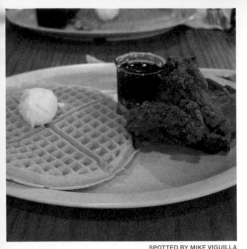

SWEET	——————■————	SAVORY
COLD	——————————■——	HOT
LIGHT	——————————————■	HEAVY

ORIGIN: United States of America

TYPICAL INGREDIENTS: Fried chicken, waffle, maple syrup

SPOTTED BY MIKE VIGUILLA

17 / MEAL

Chicken and Waffles

/CHICK-en and WAH-fulls/ This classic sweet and salty combination hails from the nineteenth-century American South. It usually consists of fried chicken on a crisp waffle, topped with maple syrup. Is there hot sauce on the table? If so, give your bird a squirt with the spicy stuff. Chicken and waffles may be served for breakfast or dinner. A Pennsylvania Dutch version forgoes the syrup in favor of stewed chicken with gravy over waffles.

I spotted this

ON:

AT:

WITH:

WANT

TRIED

LOVED

My thoughts

TASTES LIKE:

☆☆☆☆☆
FLAVOR

FEELS LIKE:

☆☆☆☆☆
TEXTURE

SMELLS LIKE:

☆☆☆☆☆
AROMA

LOOKS LIKE:

☆☆☆☆☆
APPEARANCE

SOUNDS LIKE:

☆☆☆☆☆
NOISE

ADDITIONAL NOTES:

HOW IT MADE ME FEEL

♡♡♡♡♡
OVERALL

SWEET	■----------	SAVORY
COLD	-------■---	HOT
LIGHT	----■------	HEAVY

ORIGIN: Spain

TYPICAL INGREDIENTS: Fried dough, sugar, drinking chocolate

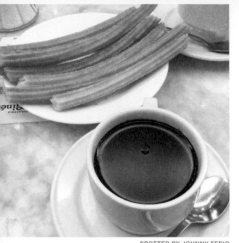

SPOTTED BY JOHNNY FERIO

Churros con Chocolate

/CHU-rows kohn cho-co-LOT-tay/ Churros are pastries made from a simple batter that is squeezed through a star-shaped nozzle into hot oil and fried. Spain serves sugar-dusted churros with a thick drinking chocolate so you can dip the churros, and then sip the remaining chocolate. The ridges on churros mean that each one is crunchy on the outside and doughy in the center. Some are even filled with chocolate, dulce de leche, or guava. In Uruguay, they make a version filled with cheese. Churros come in many shapes and sizes. To sample a longer, fatter churro, hunt for *porra*. In the United States, churros are often sprinkled with cinnamon-sugar.

spotted this

ON:

AT:

WITH:

My thoughts

TASTES LIKE:

☆ ☆ ☆ ☆ ☆
FLAVOR

FEELS LIKE:

☆ ☆ ☆ ☆ ☆
TEXTURE

SMELLS LIKE:

☆ ☆ ☆ ☆ ☆
AROMA

LOOKS LIKE:

☆ ☆ ☆ ☆ ☆
APPEARANCE

SOUNDS LIKE:

☆ ☆ ☆ ☆ ☆
NOISE

ADDITIONAL NOTES:

HOW IT MADE ME FEEL

♡ ♡ ♡ ♡ ♡
OVERALL

ORIGIN: China

TYPICAL INGREDIENTS:
Steamed dumplings, rice noodle rolls, sautéed vegetables, baked buns, soup, prepared meats

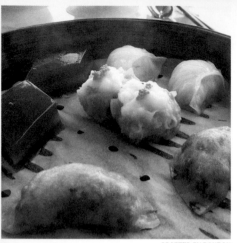

SPOTTED BY BONBON

Dim Sum

/**dim sum**/ *Dim sum* (meaning "touch the heart") is a category of small dishes that originated as a morning and early afternoon snack in Chinese tea houses. At a dim sum restaurant, you either fill out an order form with what you want to eat or carts come by your table and you select from steamer baskets. Two of the most popular dim sum dishes are *shumai*, ground pork or seafood dumplings with frilly, crimped edges and exposed tops, and *char siu bao*, baked or steamed buns with a sweet pork barbeque filling. Other things you'll find: fried chicken feet, sautéed vegetables like pea shoots and bok choy, spareribs, firm and textured radish cakes, the pink-glowing shrimp dumpling *har gow*, deep-fried balls of smooth sticky rice wrapped around tasty filling, and the delicate soup-in-a-bite *xiao long bao*. For dessert, pick from custard egg tarts, sesame balls, or mango pudding.

spotted this

ON:

AT:

WITH:

WANT

TRIED

LOVED

My thoughts

TASTES LIKE:

☆ ☆ ☆ ☆ ☆

FLAVOR

FEELS LIKE:

☆ ☆ ☆ ☆ ☆

TEXTURE

SMELLS LIKE:

☆ ☆ ☆ ☆ ☆

AROMA

LOOKS LIKE:

☆ ☆ ☆ ☆ ☆

APPEARANCE

SOUNDS LIKE:

☆ ☆ ☆ ☆ ☆

NOISE

ADDITIONAL NOTES:

HOW IT MADE ME FEEL

♡ ♡ ♡ ♡ ♡

OVERALL

SWEET	━━━━━	■ SAVORY
COLD	━━■━━	HOT
LIGHT	━━━■━	HEAVY

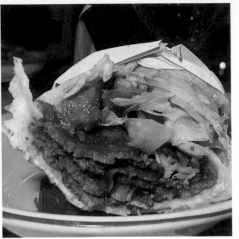

ORIGIN: Turkey

TYPICAL INGREDIENTS: Meat, flatbread, cucumbers, tomato, yogurt sauce

SPOTTED BY SEBNEM

Döner Kebab

/DOE-nuhr key-BOB/ This nearly universal Turkish dish is a hand-held pocket of meat and zingy flavors in a to-go wrap. To start, the restaurant stacks whole slices of raw lamb, beef, veal, or chicken on a vertical rotisserie. The cone-shaped meat rotates beside a heat source until the outside layer is cooked; then it is gently sliced off vertically for each order. The marinated meat is served in either an overstuffed pita or lavash wrap with lettuce, tomato, onion, cucumber, chili sauce, and yogurt sauce. The Arabic version is *shawarma*, or, in Greece, a *gyro*. In Mexico, this style of meat is said to be *al pastor*.

spotted this

ON:

AT:

WITH:

WANT

TRIED

LOVED

My thoughts

TASTES LIKE:

☆ ☆ ☆ ☆ ☆
FLAVOR

FEELS LIKE:

☆ ☆ ☆ ☆ ☆
TEXTURE

SMELLS LIKE:

☆ ☆ ☆ ☆ ☆
AROMA

LOOKS LIKE:

☆ ☆ ☆ ☆ ☆
APPEARANCE

SOUNDS LIKE:

☆ ☆ ☆ ☆ ☆
NOISE

ADDITIONAL NOTES:

HOW IT MADE ME FEEL

♡ ♡ ♡ ♡ ♡
OVERALL

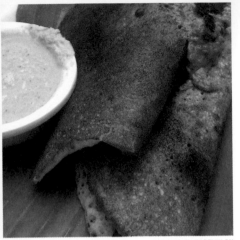

SWEET	———————	■ SAVORY
COLD	——■———	HOT
LIGHT	——————■—	HEAVY

ORIGIN: India

TYPICAL INGREDIENTS: Rice and lentil crêpe, ghee

SPOTTED BY KARTHIK GK

21 / MEAL

Dosa

/DOE-suh/ This Indian specialty is made from a lightly fermented ground rice and lentil batter, which gives the dosa a pleasantly tangy flavor. The extraordinarily thin, crisp disk is cooked on a griddle and served either rolled or folded. A dosa may come prepared simply with ghee (clarified butter) or with stuffings. *Masala dosa* is filled with spiced potatoes. Other fillings include cabbage, *paneer* (cheese), spinach, and onions. Paper dosa is an extra-crisp 2-ft-/60-cm-long unfilled version served with *sambar*, a kind of vegetable stew, and chutney. In Singapore, it is called *thosai*; in Myanmar, *toshay*. *Rava dosa* is made with an unfermented semolina flour batter instead of the more common ground rice and lentils.

spotted this

ON:

AT:

WITH:

WANT

TRIED

LOVED

My thoughts

TASTES LIKE:

☆ ☆ ☆ ☆ ☆
FLAVOR

FEELS LIKE:

☆ ☆ ☆ ☆ ☆
TEXTURE

SMELLS LIKE:

☆ ☆ ☆ ☆ ☆
AROMA

LOOKS LIKE:

☆ ☆ ☆ ☆ ☆
APPEARANCE

SOUNDS LIKE:

☆ ☆ ☆ ☆ ☆
NOISE

ADDITIONAL NOTES:

HOW IT MADE ME FEEL

♡ ♡ ♡ ♡ ♡
OVERALL

SPOTTED BY INTROVERTLY BUBBLY

SWEET ——————■—— SAVORY
COLD ——————■—— HOT
LIGHT ——————■—— HEAVY

ORIGIN: Trinidad

TYPICAL INGREDIENTS:
Flatbread, chickpeas,
chutney, pepper sauce

22 / SNACK

Doubles

/DUH-bulls/ This Trinidadian street food starts with two yellow, turmeric-laced flatbreads called *bara*. A good example is light and chewy, but never over-fried and stiff. Piled on top is *channa* (curried garbanzo or chickpeas), a spoon of mango chutney, and pepper sauce. While doubles were heavily influenced by Indian *chole bature*, the bread, chutney, and pepper sauce are uniquely Trinidadian. Doubles originated in the 1930s with the Deen family, who served them from iconic yellow boxes on bicycles. They are usually enjoyed for breakfast or as a late-night snack.

spotted this

ON:

AT:

WITH:

WANT

TRIED

LOVED

My thoughts

TASTES LIKE:

☆ ☆ ☆ ☆ ☆
FLAVOR

FEELS LIKE:

☆ ☆ ☆ ☆ ☆
TEXTURE

SMELLS LIKE:

☆ ☆ ☆ ☆ ☆
AROMA

LOOKS LIKE:

☆ ☆ ☆ ☆ ☆
APPEARANCE

SOUNDS LIKE:

☆ ☆ ☆ ☆ ☆
NOISE

ADDITIONAL NOTES:

HOW IT MADE ME FEEL

♡ ♡ ♡ ♡ ♡
OVERALL

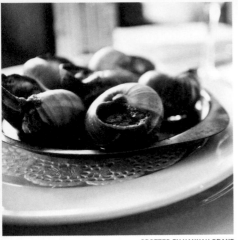

SWEET	———————	SAVORY
COLD	———————	HOT
LIGHT	———————	HEAVY

ORIGIN: France

TYPICAL INGREDIENTS: Snails, parsley, garlic butter or other sauce

23 / SNACK

Escargot

/ehs-car-GO/ Escargot is a classic French dish of snails, prepared with butter and herbs. Several particular species of snail are used. Fed cornmeal until their previous meal is no longer in their belly, the snails are shelled, sautéed, put back in the cleaned shells, then topped with a garlic-butter sauce and savory herbs. In Spain, they are called *caracol* or *cargol* and prepared similarly. In Maltese cuisine, *bebbux* (snails) are cooked with wine and herbs such as basil or mint.

spotted this

ON:	AT:	WITH:	
			WANT
			TRIED
			LOVED

My thoughts

TASTES LIKE:

☆ ☆ ☆ ☆ ☆
FLAVOR

FEELS LIKE:

☆ ☆ ☆ ☆ ☆
TEXTURE

SMELLS LIKE:

☆ ☆ ☆ ☆ ☆
AROMA

LOOKS LIKE:

☆ ☆ ☆ ☆ ☆
APPEARANCE

SOUNDS LIKE:

☆ ☆ ☆ ☆ ☆
NOISE

ADDITIONAL NOTES:

HOW IT MADE ME FEEL

♡ ♡ ♡ ♡ ♡
OVERALL

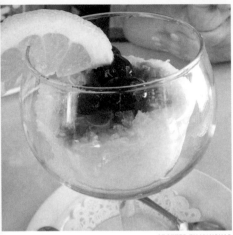

SWEET	∎∎∎—————	SAVORY
COLD	∎∎—————	HOT
LIGHT	∎∎—————	HEAVY

ORIGIN: Iran

TYPICAL INGREDIENTS: Slushy ice, rosewater, vermicelli noodles, lime juice

SPOTTED BY MAHSHAD

24 / DESSERT

Faloodeh

/fa-loo-DEH/ Even the modern palate can't resist *faloodeh*—an ancient treat of slushy ice melded with vermicelli noodles, rosewater, lime juice, and pistachios. This Persian dessert is popular throughout India and Pakistan as well. The faloodeh shouldn't be too frozen, or the noodles too long, or it will be difficult to eat. It is sometimes served with a scoop of ice cream, sherbet, or fruit syrup. In South Asia, the similarly named *falooda* is a descendant of faloodeh, except that it's more of a dessert beverage. Falooda is like Taiwanese bubble tea with vermicelli noodles and milk.

spotted this

ON:

AT:

WITH:

WANT

TRIED

LOVED

My thoughts

TASTES LIKE:

☆☆☆☆☆
FLAVOR

FEELS LIKE:

☆☆☆☆☆
TEXTURE

SMELLS LIKE:

☆☆☆☆☆
AROMA

LOOKS LIKE:

☆☆☆☆☆
APPEARANCE

SOUNDS LIKE:

☆☆☆☆☆
NOISE

ADDITIONAL NOTES:

HOW IT MADE ME FEEL

♡♡♡♡♡
OVERALL

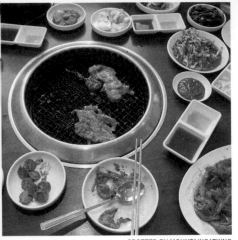

ORIGIN: Korea

TYPICAL INGREDIENTS:
Marinated short ribs, lettuce, *ssamjang*

SPOTTED BY MOUNTAINCATKING

Galbi

/call-BE/ Galbi gui literally means "grilled ribs." Galbi are marinated beef or pork short ribs. They're served with *banchan*, an assortment of Korean nibbles such as classic kimchi, vegetables (bean sprouts, spinach, and white radish), fish cakes, seaweed salad, and scallion pancake. Galbi may be served with one smooth bone along the short edge in the traditional cut or with several cut bones peeking out along the long edge in what is known as the "L.A. style." The diner usually cooks the ribs whole on a tableside grill until tender, but no longer pink. Then they're cut into strips (often with scissors) and layered with lettuce and *ssamjang* (a fermented bean paste) and chile sauce.

spotted this

ON:

AT:

WITH:

WANT

TRIED

LOVED

My thoughts

TASTES LIKE:
☆☆☆☆☆
FLAVOR

FEELS LIKE:
☆☆☆☆☆
TEXTURE

SMELLS LIKE:
☆☆☆☆☆
AROMA

LOOKS LIKE:
☆☆☆☆☆
APPEARANCE

SOUNDS LIKE:
☆☆☆☆☆
NOISE

ADDITIONAL NOTES:

HOW IT MADE ME FEEL

♡♡♡♡♡
OVERALL

SWEET	■	SAVORY
COLD	■	HOT
LIGHT	■	HEAVY

ORIGIN: Philippines

TYPICAL INGREDIENTS:
Shaved ice, evaporated milk, assorted toppings

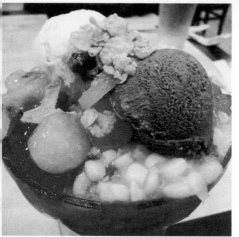

SPOTTED BY JOANNA CHOA

26 / DESSERT

Halo Halo

/**HA-loh HA-loh**/ *Halo halo* is a rich, layered Filipino dessert made with shaved or crushed ice. It combines preserved red beans and chickpeas with tropical flavors like dried rice, coconut meat, jackfruit, caramelized plantain, tapioca, and *nata de coco* (coconut jelly). It's served in a tall or wide glass to show off the layers of snowy ice and abundance of sweet mix-ins. A scoop of *ube* (purple yam) ice cream, a slice of flan, and a drizzle of sweetened evaporated milk often top off the decadence. Similar versions include Japanese *kakigori*, Indonesian *es campur*, and Chinese *baobing*.

spotted this

ON:

AT:

WITH:

WANT

TRIED

LOVED

My thoughts

TASTES LIKE:

☆ ☆ ☆ ☆ ☆
FLAVOR

FEELS LIKE:

☆ ☆ ☆ ☆ ☆
TEXTURE

SMELLS LIKE:

☆ ☆ ☆ ☆ ☆
AROMA

LOOKS LIKE:

☆ ☆ ☆ ☆ ☆
APPEARANCE

SOUNDS LIKE:

☆ ☆ ☆ ☆ ☆
NOISE

ADDITIONAL NOTES:

HOW IT MADE ME FEEL

♡ ♡ ♡ ♡ ♡
OVERALL

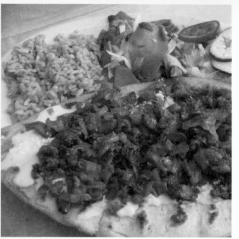

SPOTTED BY CHUCK

ORIGIN: Mexico

TYPICAL INGREDIENTS: Fried masa, grilled or stewed meats, salsa, queso fresco

27 / SNACK

Huarache

/wah-RAH-chay/ The edible huarache is shaped like the sandal for which it is named; it has a flat, oblong masa base. Fried to golden perfection, a quality huarache has crispy edges and a soft middle. It's topped with a variety of meats, salsa, potatoes, onions, shredded cabbage, and queso fresco for a meal-size snack. Originally from Mexico City, a huarache is best enjoyed outdoors or on a street corner with extra napkins. Sometimes the masa base includes a thin layer of refried beans inside. This variation is closer to huarache's predecessor, the Mexican dish *tlacoyo*. *Sopes* are similar, but a different shape.

spotted this

ON:

AT:

WITH:

WANT

TRIED

LOVED

My thoughts

TASTES LIKE:

☆ ☆ ☆ ☆ ☆
FLAVOR

FEELS LIKE:

☆ ☆ ☆ ☆ ☆
TEXTURE

SMELLS LIKE:

☆ ☆ ☆ ☆ ☆
AROMA

LOOKS LIKE:

☆ ☆ ☆ ☆ ☆
APPEARANCE

SOUNDS LIKE:

☆ ☆ ☆ ☆ ☆
NOISE

ADDITIONAL NOTES:

HOW IT MADE ME FEEL

♡ ♡ ♡ ♡ ♡
OVERALL

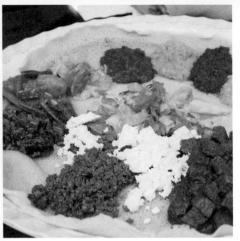

SWEET	———— ■	SAVORY
COLD	■	HOT
LIGHT	■	HEAVY

ORIGIN: Ethiopia

TYPICAL INGREDIENTS: Teff, wheat, other grains

SPOTTED BY TASTYMONTREAL

Injera

/in-JEER-ah/ When sampling Ethiopian or Eritrean food, you must eat injera, the flat, porous sourdough bread at the heart of the cuisine. Made with fermented *teff* flour batter, injera is used for both food presentation and as the main eating utensil. It's often served with spiced meat called *tibs*, lentils flavored with traditional *berbere* spices, and *wat* (Ethiopian stews). Sizable dollops of your selected meat, vegetables, and beans sit atop the platter-sized injera. This makes the bread rich with stew drippings and perfect for sopping up spicy sauce. Injera comes in varieties such as *nech* (white), *kay* (red), and *tikur* (black).

spotted this

ON:

AT:

WITH:

My thoughts

TASTES LIKE:

☆☆☆☆☆

FLAVOR

FEELS LIKE:

☆☆☆☆☆

TEXTURE

SMELLS LIKE:

☆☆☆☆☆

AROMA

LOOKS LIKE:

☆☆☆☆☆

APPEARANCE

SOUNDS LIKE:

☆☆☆☆☆

NOISE

ADDITIONAL NOTES:

HOW IT MADE ME FEEL

♡♡♡♡♡

OVERALL

SWEET	—————■—————	SAVORY
COLD	—————————■—	HOT
LIGHT	—————————■—	HEAVY

ORIGIN: Australia

TYPICAL INGREDIENTS: Bread, butter, assorted fillings

SPOTTED BY QUIE YING

29 / SNACK

Jaffle

/JAH-full/ The success of the jaffle, a.k.a. *toastie,* is directly related to the world's love of warm fillings sealed in compressed bread. In the 1970s, an appliance maker created the jaffle iron. A jaffle isn't complicated; it's just buttered bread slices filled with things like cheese and meat. Place the ingredients into the electric sandwich press and watch it crush the edges together, toast, and melt the interior. You can order a savory jaffle or one filled with sweets, like banana and hazelnut-chocolate spread. Similar toasted sandwiches are called *tosti* in the Netherlands.

spotted this

ON:

AT:

WITH:

WANT

TRIED

LOVED

My thoughts

TASTES LIKE:

☆ ☆ ☆ ☆ ☆
FLAVOR

FEELS LIKE:

☆ ☆ ☆ ☆ ☆
TEXTURE

SMELLS LIKE:

☆ ☆ ☆ ☆ ☆
AROMA

LOOKS LIKE:

☆ ☆ ☆ ☆ ☆
APPEARANCE

SOUNDS LIKE:

☆ ☆ ☆ ☆ ☆
NOISE

ADDITIONAL NOTES:

HOW IT MADE ME FEEL

♡ ♡ ♡ ♡ ♡
OVERALL

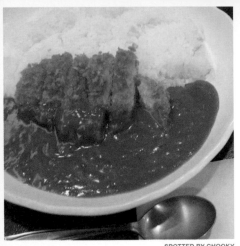

SWEET ▬ SAVORY

COLD ▬ HOT

LIGHT ▬ HEAVY

ORIGIN: Japan

TYPICAL INGREDIENTS: Fried pork cutlet, curry sauce, rice

SPOTTED BY CHOOKY

30 / MEAL

Katsu Curry

/KAHT-sue CURR-ee/ This smooth, slightly sweet and spicy Japanese-style curry is widely loved in Japan and the world abroad. It is loosely based on Indian curry, which was introduced to Japan by the British. *Katsu curry* is specifically a breaded and fried pork cutlet served with curry sauce and rice. The pork breading should be crispy, not soggy; the meat should be juicy and not too thick or leathery. The curry can be mild or very, very hot. You can also try *torikatsu* (chicken katsu), *gyukatsu* (beef katsu), *yasaikatsu* (fried vegetable) or *menchikatsu* (minced meat patties), or a *dorai kare* (minced meat curry sauce).

I spotted this

ON:

AT:

WITH:

WANT

TRIED

LOVED

My thoughts

TASTES LIKE:

☆☆☆☆☆
FLAVOR

FEELS LIKE:

☆☆☆☆☆
TEXTURE

SMELLS LIKE:

☆☆☆☆☆
AROMA

LOOKS LIKE:

☆☆☆☆☆
APPEARANCE

SOUNDS LIKE:

☆☆☆☆☆
NOISE

ADDITIONAL NOTES:

HOW IT MADE ME FEEL

♡♡♡♡♡
OVERALL

SWEET ▬▬■▬▬ SAVORY
COLD ▬▬■▬▬ HOT
LIGHT ▬■▬▬▬ HEAVY

ORIGIN: Thailand

TYPICAL INGREDIENTS:
Coconut milk, rice flour,
sugar, green onions

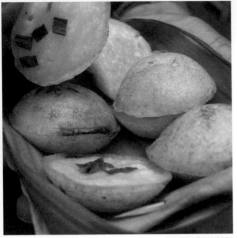

SPOTTED BY NUTOEY

31 / DESSERT

Khanom Krok

/kun-NUM KRUK/ You'll know khanom krok when you see a small boat of little jiggling half domes piled on top of each other to make tiny spheres. They are tiny coconut custard treats with a crackly outer shell containing a barely set custard. The green onion garnish offers a pleasing counterpoint to the custard's coconut milk, rice flour, and touch of sugar. The best imaginable khanom krok are made with luxuriously fresh coconut milk and in a well-loved and seasoned pan with circular indentations. They're often cooked outdoors over charcoal stoves.

spotted this

ON:

AT:

WITH:

WANT

TRIED

LOVED

My thoughts

TASTES LIKE:

☆☆☆☆☆
FLAVOR

FEELS LIKE:

☆☆☆☆☆
TEXTURE

SMELLS LIKE:

☆☆☆☆☆
AROMA

LOOKS LIKE:

☆☆☆☆☆
APPEARANCE

SOUNDS LIKE:

☆☆☆☆☆
NOISE

ADDITIONAL NOTES:

HOW IT MADE ME FEEL

♡♡♡♡♡
OVERALL

SPOTTED BY THORANIN TRIWIT

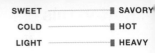

SWEET	▮ SAVORY
COLD	▮ HOT
LIGHT	▮ HEAVY

ORIGIN: Thailand

TYPICAL INGREDIENTS: Curry broth, fried egg noodles, boiled egg noodles, beef, chicken, pickled mustard greens, shallots, lime juice, chili sauce, coconut milk

32 / MEAL

Khao Soi

/COW soy/ Perhaps the ultimate dish for spicy noodle soup lovers, *khao soi* is a Thai dish influenced by the Burmese dish *on ne khauk swe*. It's commonly found in the northern city of Chiang Mai in Thailand. The extraordinarily spicy broth showcases the soup's brilliant coconut curry flavor. The soup contains slow-simmered, incredibly tender beef and chicken topped with a nest of fried egg noodles, pickled mustard greens or cabbage, and a small hill of *nam prik pao* (Thai chili sauce). Use the lime half provided to squeeze one final flavor into the khao soi bowl. The Lao version of this dish uses pork, tomatoes, and fermented soy beans and is a very different sort of soup.

spotted this

ON:

AT:

WITH:

WANT

TRIED

LOVED

My thoughts

TASTES LIKE:

☆☆☆☆☆
FLAVOR

FEELS LIKE:

☆☆☆☆☆
TEXTURE

SMELLS LIKE:

☆☆☆☆☆
AROMA

LOOKS LIKE:

☆☆☆☆☆
APPEARANCE

SOUNDS LIKE:

☆☆☆☆☆
NOISE

ADDITIONAL NOTES:

HOW IT MADE ME FEEL

♡♡♡♡♡
OVERALL

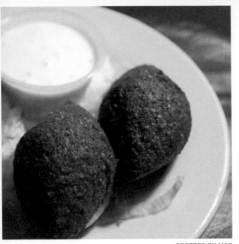

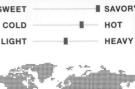

SWEET	————————————— ■	SAVORY
COLD	———————— ■	HOT
LIGHT	————————— ■	HEAVY

ORIGIN: Lebanon

TYPICAL INGREDIENTS: Bulgur wheat, onions, ground meat

SPOTTED BY MAC

33 / SNACK

Kibbeh

/KIP-eh/ Found throughout the Middle East, but also in some South American and Caribbean cultures, *kibbeh* is made from bulgur wheat, onions, and ground meat (typically lamb or beef). The kibbeh paste is usually formed around a wad of seasoned ground meat to look like a small football and deep fried. Once out of the fryer, kibbeh is best enjoyed with one swift dunk in tahini sauce. It is sometimes cooked into a pot pie–like casserole with layers of the wheat and meat mixture. Many types of spices, such as sumac, and toppings, such as yogurt, are used to flavor variations of kibbeh. It may also be boiled or baked in various shapes such as a disk or square.

I spotted this

ON:

AT:

WITH:

WANT

TRIED

LOVED

My thoughts

TASTES LIKE:

☆☆☆☆☆
FLAVOR

FEELS LIKE:

☆☆☆☆☆
TEXTURE

SMELLS LIKE:

☆☆☆☆☆
AROMA

LOOKS LIKE:

☆☆☆☆☆
APPEARANCE

SOUNDS LIKE:

☆☆☆☆☆
NOISE

ADDITIONAL NOTES:

HOW IT MADE ME FEEL

♡♡♡♡♡
OVERALL

SWEET	——————■	SAVORY
COLD	———■——	HOT
LIGHT	————■—	HEAVY

ORIGIN: Iran

TYPICAL INGREDIENTS: Meat, vegetables, spices, tomato-based gravy

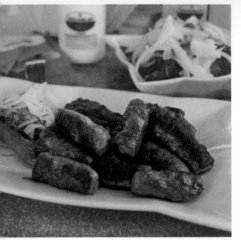

SPOTTED BY SALIHA

Kofta

/COF-tah/ *Koftas* are meatballs found throughout South Asia, the Middle East, and the Mediterranean. They're made with ground meat, vegetables, or a combination of both; spices vary by culture and koftas are served plain or in gravy. Turkish koftas use beef or lamb, while Pakistani and Iranian koftas might contain beef, lamb, or other types of meat like mutton. You will find koftas grilled, fried, baked, and prepared in just about every cooking fashion you can imagine. If the meat base is around a skewer, you have a *kofta kebab*. An extra-large meatball with a hard-boiled egg or chicken in it is *kofta tabrizi*. There's also the South Indian vegetarian kofta made with potatoes called *malai kofta*.

spotted this

ON:	AT:	WITH:	WANT
		TRIED	
		LOVED	

My thoughts

TASTES LIKE:

☆ ☆ ☆ ☆ ☆
FLAVOR

FEELS LIKE:

☆ ☆ ☆ ☆ ☆
TEXTURE

SMELLS LIKE:

☆ ☆ ☆ ☆ ☆
AROMA

LOOKS LIKE:

☆ ☆ ☆ ☆ ☆
APPEARANCE

SOUNDS LIKE:

☆ ☆ ☆ ☆ ☆
NOISE

ADDITIONAL NOTES:

HOW IT MADE ME FEEL

♡ ♡ ♡ ♡ ♡
OVERALL

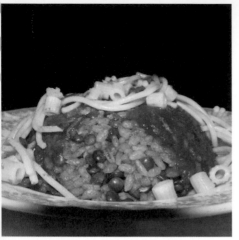

SPOTTED BY YATHREB, NOORAN YEHIA'S MUM

ORIGIN: Egypt

TYPICAL INGREDIENTS: Rice, beans, pasta, tomato sauce, hot sauce

35 / MEAL

Koshary

/CO-sherry/ Koshary is a heavy-duty Egyptian street food of the people. It defies culinary tradition with a carefully concocted balancing act of rice, then spaghetti or macaroni (sometimes both), lentils and chickpeas (again, both), and fried onion. A cumin-flavored tomato sauce is spooned over the bowl and topped with garlic vinegar and a drizzle of hot sauce. In each bite, there's crunch, tang, colorful spices, firm beans, and slippery noodles.

spotted this

ON:

AT:

WITH:

WANT

TRIED

LOVED

My thoughts

TASTES LIKE:

☆ ☆ ☆ ☆ ☆
FLAVOR

FEELS LIKE:

☆ ☆ ☆ ☆ ☆
TEXTURE

SMELLS LIKE:

☆ ☆ ☆ ☆ ☆
AROMA

LOOKS LIKE:

☆ ☆ ☆ ☆ ☆
APPEARANCE

SOUNDS LIKE:

☆ ☆ ☆ ☆ ☆
NOISE

ADDITIONAL NOTES:

HOW IT MADE ME FEEL

♡ ♡ ♡ ♡ ♡
OVERALL

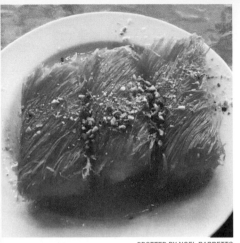

SWEET		SAVORY
COLD		HOT
LIGHT		HEAVY

ORIGIN: Palestine, particularly Nablus

TYPICAL INGREDIENTS: Kunafa pastry, sugar syrup, cheese, pistachios

SPOTTED BY NOEL BARRETTO

Kunafa

/koo-NAH-fah/ Like many Palestinian sweet treats, *kunafa* or *kunafeh* is eye-catching and super-sugary with a savory twist. This breakfast or dessert has a shredded-wheat texture, which you will notice with every bite. When made with long, thin noodles, it is *knishnah*; with coarsely ground semolina flour, it is *na'ama*; when made with both, it is *mhayara*. It is typically layered with soft cheese, then soaked with sugar syrup and topped with crushed pistachios. The traditional Palestinian additions of fragrant rosewater or orange blossom water often flavor the syrup. The top layer of pastry may be colored a vibrant orange. Keep an eye out for Turkish *künefe* and Greek *kadaif* variations.

spotted this

ON:

AT:

WITH:

WANT

TRIED

LOVED

My thoughts

TASTES LIKE:

☆☆☆☆☆
FLAVOR

FEELS LIKE:

☆☆☆☆☆
TEXTURE

SMELLS LIKE:

☆☆☆☆☆
AROMA

LOOKS LIKE:

☆☆☆☆☆
APPEARANCE

SOUNDS LIKE:

☆☆☆☆☆
NOISE

ADDITIONAL NOTES:

HOW IT MADE ME FEEL

♡♡♡♡♡
OVERALL

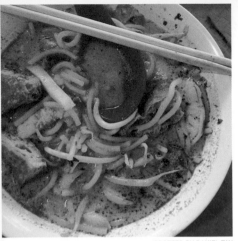

ORIGIN: Malaysia

TYPICAL INGREDIENTS: Broth, rice noodles, meat, herbs

SPOTTED BY DANIEL TAY

37 / MEAL

Laksa

/LOCK-sah/ If you love spicy food and noodle soup, then laksa is a dish especially for you. The two main types are curry laksa, which uses a coconut curry base and a lot of spicy *sambal*, and *asam laksa*, which has fish, other seafood, and a tangy tamarind kick. You may find bean curd puffs, bean sprouts, shrimp, cockles, chicken, or, in the case of a regional Penang specialty, congealed pork blood in addition to the soup noodles and broth. There are many types of broth, noodle, and meat combinations, depending on the country and region you are in.

I spotted this

ON:	AT:	WITH:	
			WANT
			TRIED
			LOVED

My thoughts

TASTES LIKE:

☆☆☆☆☆
FLAVOR

FEELS LIKE:

☆☆☆☆☆
TEXTURE

SMELLS LIKE:

☆☆☆☆☆
AROMA

LOOKS LIKE:

☆☆☆☆☆
APPEARANCE

SOUNDS LIKE:

☆☆☆☆☆
NOISE

ADDITIONAL NOTES:

HOW IT MADE ME FEEL

♡♡♡♡♡
OVERALL

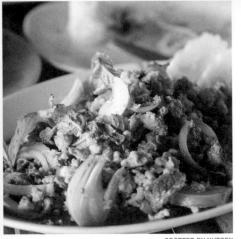

SWEET	————■————	SAVORY
COLD	————■————	HOT
LIGHT	——■————	HEAVY

ORIGIN: Laos

TYPICAL INGREDIENTS:
Ground meat, mint, onion,
ground toasted rice

38 / SIDE

Larb

/LAR-buh/ The national dish of Laos, this salad is made with *moo*
(ground pork), *gai* (chicken), or *ped* (duck). There are also basil, mint,
and bright red chili flakes. Lime juice and fish sauce add spicy and sour
flavors, while finely ground toasted rice is an essential addition to the
dish. Eaters use cabbage leaves, lettuce, or cucumber slices to scoop up
bites of salad. A variation called *saa* is made with minced pork or fish,
banana blossoms, and bean thread noodles.

spotted this

ON:

AT:

WITH:

WANT

TRIED

LOVED

My thoughts

TASTES LIKE:

☆ ☆ ☆ ☆ ☆
FLAVOR

FEELS LIKE:

☆ ☆ ☆ ☆ ☆
TEXTURE

SMELLS LIKE:

☆ ☆ ☆ ☆ ☆
AROMA

LOOKS LIKE:

☆ ☆ ☆ ☆ ☆
APPEARANCE

SOUNDS LIKE:

☆ ☆ ☆ ☆ ☆
NOISE

ADDITIONAL NOTES:

HOW IT MADE ME FEEL

♡ ♡ ♡ ♡ ♡
OVERALL

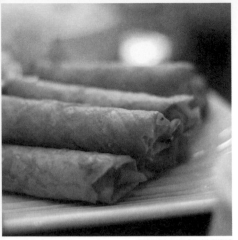

SPOTTED BY ALFONSO TUPAZ

SWEET ———————— ▮ SAVORY
COLD ————————— ▮ HOT
LIGHT ————————— ▮ HEAVY

ORIGIN: China, but considered Filipino

TYPICAL INGREDIENTS: Ground pork, carrots, lumpia wrappers, eggs

39 / SNACK

Lumpia

/LOOM-pee-ah/ This classic Filipino and Indonesian snack looks most like a long, thin egg roll. It originated in China with fried spring rolls and was disseminated by emigrants. You may find ground pork or beef, shredded carrots, onion, and cilantro inside paper-thin lumpia wrappers. They are often fried, but *lumpiang sariwa* is a fresh version similar to Chinese spring rolls. If it is fried and served with sweet and sour sauce, that's *lumpia Shanghai*. Countless variants can be found. In the Netherlands, *loempia* is the name for any spring roll.

spotted this

ON:

AT:

WITH:

WANT

TRIED

LOVED

My thoughts

TASTES LIKE:

☆☆☆☆☆
FLAVOR

FEELS LIKE:

☆☆☆☆☆
TEXTURE

SMELLS LIKE:

☆☆☆☆☆
AROMA

LOOKS LIKE:

☆☆☆☆☆
APPEARANCE

SOUNDS LIKE:

☆☆☆☆☆
NOISE

ADDITIONAL NOTES:

HOW IT MADE ME FEEL

♡♡♡♡♡
OVERALL

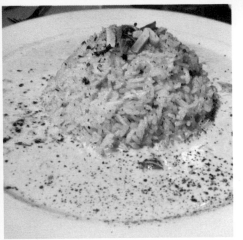

SWEET	SAVORY
COLD	HOT
LIGHT	HEAVY

ORIGIN: Jordan

TYPICAL INGREDIENTS:
Saffron rice, lamb, flatbread, yogurt sauce

SPOTTED BY VERLISIA

Mansaf

/man-SIF/ The making and eating of mansaf, a Jordanian national dish, feels very ancient. It is made from a whole lamb cooked in dried, fermented yogurt until it is fall-apart tender. Then the lamb is layered on flatbread with saffron rice or bulgur. Finally, toasted nuts, ladles of the sauce, and parsley finish the presentation. Traditionally, the meal is eaten with the right hand, which is used to form balls of meat and rice, which are tossed into the mouth. It was originally prepared for special events only, but can now be found during more casual mealtimes.

I spotted this

ON:

AT:

WITH:

WANT

TRIED

LOVED

My thoughts

TASTES LIKE:

☆☆☆☆☆
FLAVOR

FEELS LIKE:

☆☆☆☆☆
TEXTURE

SMELLS LIKE:

☆☆☆☆☆
AROMA

LOOKS LIKE:

☆☆☆☆☆
APPEARANCE

SOUNDS LIKE:

☆☆☆☆☆
NOISE

ADDITIONAL NOTES:

HOW IT MADE ME FEEL

♡♡♡♡♡
OVERALL

SWEET ▬▬▬▬▬▬▬ ■ SAVORY
COLD ▬▬▬ ■ ▬▬▬ HOT
LIGHT ▬▬▬ ■ ▬▬▬ HEAVY

ORIGIN: Turkey

TYPICAL INGREDIENTS: Dough, ground lamb, spices

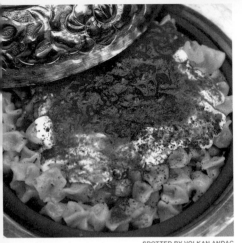

SPOTTED BY VOLKAN ANDAÇ

41 / MEAL

Manti

/MAN-tah/ Recipes for these dumplings date back to the fifteenth century, when they were frozen for traveling, then brought back to life in a pot of boiling water. Now they are popular throughout Central Asia and the Caucasus. Filled with ground lamb (or beef), minced onion, spices, and sometimes pumpkin or squash, the dumplings range from bite-size all the way to the size of a Japanese *gyoza*. They are boiled or steamed, then garnished with vinegar and chili powder or tomato sauce. In Kayseri, Turkey, prospective brides make manti for their mothers-in-law to display their kitchen skills.

spotted this

ON:

AT:

WITH:

WANT

TRIED

LOVED

My thoughts

TASTES LIKE:

☆☆☆☆☆
FLAVOR

FEELS LIKE:

☆☆☆☆☆
TEXTURE

SMELLS LIKE:

☆☆☆☆☆
AROMA

LOOKS LIKE:

☆☆☆☆☆
APPEARANCE

SOUNDS LIKE:

☆☆☆☆☆
NOISE

ADDITIONAL NOTES:

HOW IT MADE ME FEEL

♡♡♡♡♡
OVERALL

SWEET ·········· ▮ SAVORY
COLD ········ ▮ ········ HOT
LIGHT ·········· ▮ HEAVY

ORIGIN: Australia

TYPICAL INGREDIENTS: Beef, gravy, pastry crust

42 / SNACK

Meat Pie

/MEAT pie/ Essential components of the iconic meat pie include a light and flaky crust, high-quality diced or ground meat, gravy, and sometimes carrots, potatoes, or other vegetables. Aussies recommend eating meat pies with beer, chocolate milk, or iced coffee. They are primarily convenience foods and fare for sporting events. Be sure to apply a big dollop of tomato sauce (that's Australian for ketchup) and to spread it around the top. Pie contests are common throughout Australia and New Zealand. Steak pies in the United Kingdom are similar.

spotted this

ON:

AT:

WITH:

WANT

TRIED

LOVED

My thoughts

TASTES LIKE:

☆ ☆ ☆ ☆ ☆
FLAVOR

FEELS LIKE:

☆ ☆ ☆ ☆ ☆
TEXTURE

SMELLS LIKE:

☆ ☆ ☆ ☆ ☆
AROMA

LOOKS LIKE:

☆ ☆ ☆ ☆ ☆
APPEARANCE

SOUNDS LIKE:

☆ ☆ ☆ ☆ ☆
NOISE

ADDITIONAL NOTES:

HOW IT MADE ME FEEL

♡ ♡ ♡ ♡ ♡
OVERALL

SWEET	—————■———————	SAVORY
COLD	———————————■———	HOT
LIGHT	——■———————————	HEAVY

ORIGIN: Japan

TYPICAL INGREDIENTS:
Glutinous rice

SPOTTED BY TOUCHAN

43 / DESSERT

Mochi

/MOH-chee/ Glutinous sticky rice is the key ingredient in mochi, a Japanese confection. Traditionally, rice was pounded until smooth using a giant wooden mortar and pestle; today it can be made by machine. It can be formed into palm-size balls that are sticky, chewy, and delightful to eat; your bite may even reveal a filling like red bean paste or ice cream (making it a *daifuku*). Especially popular around New Year, mochi comes in many varieties. While you might have seen bits used to top frozen yogurt, it can also be wrapped in fragrant cherry leaves, which is known as *sakura mochi*, served on a stick and called *dango*, or even shaped into waffles. Baked creations like butter mochi are a distinct part of Hawaiian cuisine.

spotted this

ON:

AT:

WITH:

WANT

TRIED

LOVED

My thoughts

TASTES LIKE:

☆☆☆☆☆
FLAVOR

FEELS LIKE:

☆☆☆☆☆
TEXTURE

SMELLS LIKE:

☆☆☆☆☆
AROMA

LOOKS LIKE:

☆☆☆☆☆
APPEARANCE

SOUNDS LIKE:

☆☆☆☆☆
NOISE

ADDITIONAL NOTES:

HOW IT MADE ME FEEL

♡♡♡♡♡
OVERALL

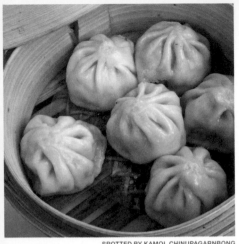

SWEET ——————— ■ SAVORY
COLD ——————— ■ HOT
LIGHT ——————— ■ HEAVY

ORIGIN: Nepal

TYPICAL INGREDIENTS: Dough, ground meat, onion, garlic, dipping sauce

SPOTTED BY KAMOL CHINUPAGARNBONG

44 / SNACK

Momo

/MOH-moh/ A good Nepalese *momo* is like many dumplings, although the flavors are distinctive; momos are filled with meat such as water buffalo, yak, goat, and lamb. The meat may be seasoned with any combination of ingredients like onions, garlic, ginger, and cilantro. The wrapper is sometimes made with yeast, which makes the exterior doughy. Momos may be half-moons or perfect circles with top folds (like *baozi*), and steamed, pan-fried, or deep-fried. They are often served with hot sauce or puréed tomato sauce for dipping. Bhutanese momos often contain cheese.

spotted this

ON:

AT:

WITH:

WANT

TRIED

LOVED

My thoughts

TASTES LIKE:

☆☆☆☆☆
FLAVOR

FEELS LIKE:

☆☆☆☆☆
TEXTURE

SMELLS LIKE:

☆☆☆☆☆
AROMA

LOOKS LIKE:

☆☆☆☆☆
APPEARANCE

SOUNDS LIKE:

☆☆☆☆☆
NOISE

ADDITIONAL NOTES:

HOW IT MADE ME FEEL

♡♡♡♡♡
OVERALL

ORIGIN: Malaysia

TYPICAL INGREDIENTS:
Coconut rice, sambal, garnishes

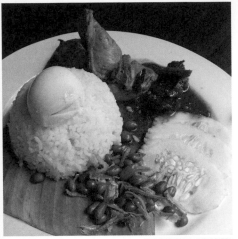

45 / MEAL

Nasi Lemak

/nah-SEE le-MOCK/ Nasi lemak translates to "fatty rice," so named because the rice is cooked in rich coconut milk. A distinctive floral, grassy flavor comes from *pandan* leaves. Nasi lemak is served any time of day on a plate with garnishes such as peanuts, fried anchovies, cucumber slices, fried fish, sambal, and egg. At food stalls, nasi lemak is often wrapped in banana leaves. In Malaysian Indian style, it is served with curry. Nasi lemak is widely enjoyed across Southeast Asia, and the spice level and meat varies with each country. The Indonesian *nasi uduk* is a similar version.

spotted this

ON:

AT:

WITH:

WANT

TRIED

LOVED

My thoughts

TASTES LIKE:

☆ ☆ ☆ ☆ ☆
FLAVOR

FEELS LIKE:

☆ ☆ ☆ ☆ ☆
TEXTURE

SMELLS LIKE:

☆ ☆ ☆ ☆ ☆
AROMA

LOOKS LIKE:

☆ ☆ ☆ ☆ ☆
APPEARANCE

SOUNDS LIKE:

☆ ☆ ☆ ☆ ☆
NOISE

ADDITIONAL NOTES:

HOW IT MADE ME FEEL

♡ ♡ ♡ ♡ ♡
OVERALL

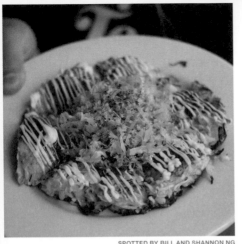

ORIGIN: Japan

TYPICAL INGREDIENTS:
Egg-based batter, toppings, mix-ins

SPOTTED BY BILL AND SHANNON NG

46 / SNACK

Okonomiyaki

/oh-KOH-noh-mee-YAH-kee/ The word *okonomiyaki* essentially means "whatever you like, cooked," so these savory pancakes have a multitude of flavors. Toppings range from pork and shrimp to mochi and *yakisoba* noodles. In Kansai-style okonomiyaki, sometimes called "Osaka soul food," cabbage, grated yam, green onions, and other toppings are mixed right into the batter. In Hiroshima-style okonomiyaki, the ingredients are layered and cooked on top of one another. In either preparation, the batter is then pan-fried. The finished pancake is brushed with sweet and tangy okonomiyaki sauce and drizzled with Kewpie mayo. Writhing bonito flakes and dried seaweed are the final touch. Some restaurants make it for you and some let you cook it at your table.

spotted this

ON:

AT:

WITH:

WANT

TRIED

LOVED

My thoughts

TASTES LIKE:

☆☆☆☆☆
FLAVOR

FEELS LIKE:

☆☆☆☆☆
TEXTURE

SMELLS LIKE:

☆☆☆☆☆
AROMA

LOOKS LIKE:

☆☆☆☆☆
APPEARANCE

SOUNDS LIKE:

☆☆☆☆☆
NOISE

ADDITIONAL NOTES:

HOW IT MADE ME FEEL

♡♡♡♡♡
OVERALL

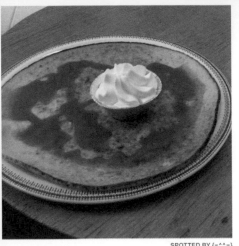

SWEET	■	SAVORY
COLD	■	HOT
LIGHT	■	HEAVY

ORIGIN: Netherlands

TYPICAL INGREDIENTS: Batter, assorted mix-in toppings

SPOTTED BY {=^^=}

Pannenkoek

/PAH-nin-cook/ This Dutch and Belgian creation looks like an oversize American pancake, but is more elastic. A thin batter is mixed with toppings like raisins, apples, cheese, or bacon before pan-cooking. It is often served with *appelstroop* (an apple butter spread), treacle, or a dusting of powdered sugar. Eaten as a main course, especially for children's birthdays, pannenkoek can be made with a wide variety of savory or sweet ingredients. The French *clafouti* is a similar dish, Austrian versions are called *kaiserschmarrn,* and Finnish pancakes are *pannukakku.*

spotted this

ON:

AT:

WITH:

WANT

TRIED

LOVED

My thoughts

TASTES LIKE:

☆ ☆ ☆ ☆ ☆
FLAVOR

FEELS LIKE:

☆ ☆ ☆ ☆ ☆
TEXTURE

SMELLS LIKE:

☆ ☆ ☆ ☆ ☆
AROMA

LOOKS LIKE:

☆ ☆ ☆ ☆ ☆
APPEARANCE

SOUNDS LIKE:

☆ ☆ ☆ ☆ ☆
NOISE

ADDITIONAL NOTES:

HOW IT MADE ME FEEL

♡ ♡ ♡ ♡ ♡
OVERALL

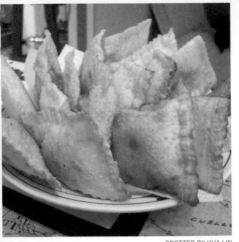

SWEET ——■—— SAVORY
COLD ———■— HOT
LIGHT ——■—— HEAVY

ORIGIN: Brazil

TYPICAL INGREDIENTS: Pastry crust, assorted fillings

SPOTTED BY HUA LIN

48 / SNACK

Pastel

/*PAHSCH-tell*/ The Brazilian pastel is a portable snack of a rectangular or half-circle turnover freshly made and deep-fried. Using a bit of *cachaça* (fermented sugarcane liquor) in the dough supposedly causes the bubbly crust. Tucked into the center of each pastel you'll find ground meat, shredded chicken, hearts of palm, cream cheese, or shrimp. Sweet versions may contain guava jam, banana, or chocolate. Pastels should be blistered and light on the outside. You shouldn't confuse the Brazilian pastel with the Colombian pastel, which is closer to a wrapped corn tamale. There's even *pastel de nata*, a popular Portuguese egg custard tart. *Pastel* generally translates to "cake" in Spanish, so double-check what you're getting before you order more than one.

spotted this

ON:

AT:

WITH:

WANT

TRIED

LOVED

My thoughts

TASTES LIKE:

☆☆☆☆☆
FLAVOR

FEELS LIKE:

☆☆☆☆☆
TEXTURE

SMELLS LIKE:

☆☆☆☆☆
AROMA

LOOKS LIKE:

☆☆☆☆☆
APPEARANCE

SOUNDS LIKE:

☆☆☆☆☆
NOISE

ADDITIONAL NOTES:

HOW IT MADE ME FEEL

♡♡♡♡♡
OVERALL

SWEET ▮————————— SAVORY
COLD ——▮—————— HOT
LIGHT ▮————————— HEAVY

ORIGIN: New Zealand

TYPICAL INGREDIENTS:
Meringue, fresh fruit,
whipped cream

SPOTTED BY THE VERY HUNGRY KATERPILLA

49 / DESSERT

Pavlova

/pav-LOH-vuh/ Allegedly inspired by ballerina Anna Pavlova's visit to
New Zealand in the 1920s, this dessert is almost lighter than air, just like
a dancer. The base of the dish, baked meringue, starts with a delicate
crunch but nearly evaporates in your mouth almost as soon as your
taste buds register the flavor. It's sweet, but the natural tartness of kiwi,
mango, or strawberries piled on top balances the flavor. Whipped cream
is the usual garnish. Often served in the summer and for holidays, pav-
lovas may be individual or large creations meant to share.

I spotted this

ON:

AT:

WITH:

WANT

TRIED

LOVED

My thoughts

TASTES LIKE:

☆☆☆☆☆
FLAVOR

FEELS LIKE:

☆☆☆☆☆
TEXTURE

SMELLS LIKE:

☆☆☆☆☆
AROMA

LOOKS LIKE:

☆☆☆☆☆
APPEARANCE

SOUNDS LIKE:

☆☆☆☆☆
NOISE

ADDITIONAL NOTES:

HOW IT MADE ME FEEL

♡♡♡♡♡
OVERALL

SWEET	▉ SAVORY
COLD	▉ HOT
LIGHT	▉ HEAVY

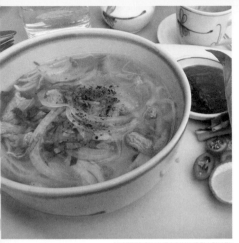

SPOTTED BY LINDA DINH (BELLENAFI)

ORIGIN: Vietnam

TYPICAL INGREDIENTS: Rice noodles, beef broth, meat, herbs, vegetable toppings

Phở

/fuh/ *Phở* is an addictive dish that looks deceptively simple but is actually a complex creation. A nest of cool, cooked rice noodles is placed into a large round bowl and then clear, savory broth made by boiling beef marrow bones is poured over it. It might contain thin pieces of raw beef, tripe, tendon, or meatballs. You may also receive a plate of basil, bean sprouts, jalapeños, and lime wedges to add to the bowl. You'll encounter a few varieties of phở. The southern Saigon style is most common. Northern-style phở is characterized by crystal-clear broth and wide noodles. *Phở gà* is made with chicken.

spotted this

ON:

AT:

WITH:

My thoughts

TASTES LIKE:

☆ ☆ ☆ ☆ ☆
FLAVOR

FEELS LIKE:

☆ ☆ ☆ ☆ ☆
TEXTURE

SMELLS LIKE:

☆ ☆ ☆ ☆ ☆
AROMA

LOOKS LIKE:

☆ ☆ ☆ ☆ ☆
APPEARANCE

SOUNDS LIKE:

☆ ☆ ☆ ☆ ☆
NOISE

ADDITIONAL NOTES:

HOW IT MADE ME FEEL

♡ ♡ ♡ ♡ ♡
OVERALL

SWEET	━━━━━ ▮	SAVORY
COLD	━━━━━ ▮	HOT
LIGHT	━━━━━ ▮	HEAVY

ORIGIN: Poland

TYPICAL INGREDIENTS: Dough, assorted fillings

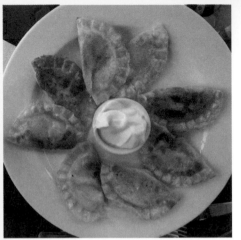

51 / MEAL

Pierogi

/PEA-row-ghee/ These unleavened Polish dumplings are also a staple of other Eastern European countries and places where those immigrants have settled, such as the American Northeast. The doughy, crescent-shaped skins are filled with everything from sauerkraut, cheese, and potatoes to blueberries and cherries. The dough is often mixed with mashed potatoes to create a smooth texture. Pierogi are popular in Canada, where you might find them stuffed with regional fillings like Saskatoon berry jam. Pierogi are usually boiled, then given a quick pan sauté with butter.

spotted this

ON:

AT:

WITH:

WANT

TRIED

LOVED

My thoughts

TASTES LIKE:

☆☆☆☆☆
FLAVOR

FEELS LIKE:

☆☆☆☆☆
TEXTURE

SMELLS LIKE:

☆☆☆☆☆
AROMA

LOOKS LIKE:

☆☆☆☆☆
APPEARANCE

SOUNDS LIKE:

☆☆☆☆☆
NOISE

ADDITIONAL NOTES:

HOW IT MADE ME FEEL

♡♡♡♡♡
OVERALL

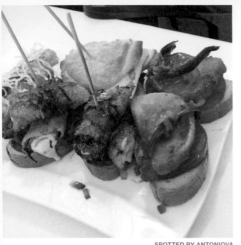

ORIGIN: Spain

TYPICAL INGREDIENTS: Bread, assorted seafood, meat, and vegetables

SPOTTED BY ANTONIOVA

52 / SNACK

Pinchos

/PEEN-chos/ Famously served in Spain's northern Basque countryside, *pinchos* or *pintxos* are small snacks served barside; they're best enjoyed with a drink and fellowship. Pinchos are named after the toothpick used to hold vertically stacked ingredients together on top of bread. Common components include seafood, cured meats, cheese, and pickled or fresh vegetables with herbs. The restaurant might even serve the toothpickless *tortilla de patatas* or *croquetas de jamón* (fried ham balls). *Pinchos* and *tapas*, meaning "small plates," might be used interchangeably in Spain. Don't confuse them with Latin American pinchos, which are cooked meat skewers.

I spotted this

ON:

AT:

WITH:

WANT

TRIED

LOVED

My thoughts

TASTES LIKE:

☆ ☆ ☆ ☆ ☆
FLAVOR

FEELS LIKE:

☆ ☆ ☆ ☆ ☆
TEXTURE

SMELLS LIKE:

☆ ☆ ☆ ☆ ☆
AROMA

LOOKS LIKE:

☆ ☆ ☆ ☆ ☆
APPEARANCE

SOUNDS LIKE:

☆ ☆ ☆ ☆ ☆
NOISE

ADDITIONAL NOTES:

HOW IT MADE ME FEEL

♡ ♡ ♡ ♡ ♡
OVERALL

SWEET ——————— ▋ SAVORY

COLD ———— ▋—— HOT

LIGHT ———— ▋—— HEAVY

ORIGIN: Mozambique

TYPICAL INGREDIENTS: Piri piri peppers, chicken

SPOTTED BY WAYNE TONG

53 / MEAL

Piri Piri Chicken

/PEE-ree PEE-ree CHICK-en/ Chicken is an important part of piri piri chicken, but it's not the star of the dish; the pepper sauce is the main attraction. The pepper is native to southern Africa, but the sauce wasn't created until Portuguese settlers arrived. Piri piri peppers are little red firecrackers and pack a lot of heat. Chicken is marinated in a sauce of piri piri, lemon juice, onion, garlic, and other spices; then it is grilled. The result is juicy, slightly charred, and 100 percent mouthwatering.

spotted this

ON:

AT:

WITH:

WANT

TRIED

LOVED

My thoughts

TASTES LIKE:

☆ ☆ ☆ ☆ ☆
FLAVOR

FEELS LIKE:

☆ ☆ ☆ ☆ ☆
TEXTURE

SMELLS LIKE:

☆ ☆ ☆ ☆ ☆
AROMA

LOOKS LIKE:

☆ ☆ ☆ ☆ ☆
APPEARANCE

SOUNDS LIKE:

☆ ☆ ☆ ☆ ☆
NOISE

ADDITIONAL NOTES:

HOW IT MADE ME FEEL

♡ ♡ ♡ ♡ ♡
OVERALL

SWEET	——————	∎ SAVOR
COLD	—— ∎ ——	HOT
LIGHT	——————	∎ HEAVY

ORIGIN: Canada

TYPICAL INGREDIENTS: French fries, fresh cheese curds, brown gravy

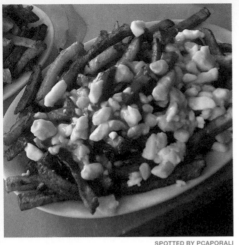

SPOTTED BY PCAPORALI

54 / SNACK

Poutine

/POO-teen/ A proper Canadian poutine is a decadent snack of thin brown gravy over crisp french fries—made slightly soft from absorbing the gravy—sprinkled with cheese curds. When you bite down on the cheese curds, you should feel a squeak in your teeth. It's such a ubiquitous food in Canada that fast-food and fine-dining restaurants alike serve it. Poutine might also be topped with shredded meat like beef, pulled pork, lamb, or rabbit. The English chips and gravy are a similar dish; American menus sometimes list them as gravy-cheese fries.

I spotted this

ON:

AT:

WITH:

WANT

TRIED

LOVED

My thoughts

TASTES LIKE:

☆ ☆ ☆ ☆ ☆
FLAVOR

FEELS LIKE:

☆ ☆ ☆ ☆ ☆
TEXTURE

SMELLS LIKE:

☆ ☆ ☆ ☆ ☆
AROMA

LOOKS LIKE:

☆ ☆ ☆ ☆ ☆
APPEARANCE

SOUNDS LIKE:

☆ ☆ ☆ ☆ ☆
NOISE

ADDITIONAL NOTES:

HOW IT MADE ME FEEL

♡ ♡ ♡ ♡ ♡
OVERALL

SWEET	─── ■ SAVORY
COLD	─── ■ HOT
LIGHT	─── ■ HEAVY

ORIGIN: El Salvador

TYPICAL INGREDIENTS: Masa, cheese, refried beans, meat

SPOTTED BY APRIL WALTERS

Pupusa

/poo-POO-sah/ Salvadoran pupusas combine cheese and corn in a simple but magical way. A crackly maize exterior encases the cheese in a thick pancake. They're made with flattened masa dough balls that are filled with cheese, refried beans, and *chicharrón* (a pork paste, not the fried rinds). The pupusas are cooked on a griddle until slightly puffed and served with *curtido* (fermented cabbage slaw), tomato salsa, and pickled veggies. In Central America and parts of the United States, the pupusa filling might use cheese blended with *loroco*, a cactus flower bud, to make *queso con loroco*. Corn flour can also be replaced with rice flour in the variation *pupusas de arroz*.

spotted this

ON:

AT:

WITH:

WANT

TRIED

LOVED

My thoughts

TASTES LIKE:

☆☆☆☆☆
FLAVOR

FEELS LIKE:

☆☆☆☆☆
TEXTURE

SMELLS LIKE:

☆☆☆☆☆
AROMA

LOOKS LIKE:

☆☆☆☆☆
APPEARANCE

SOUNDS LIKE:

☆☆☆☆☆
NOISE

ADDITIONAL NOTES:

HOW IT MADE ME FEEL

♡♡♡♡♡
OVERALL

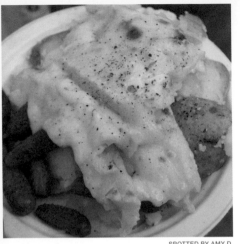

SWEET ———————— ■ SAVORY
COLD ————— ■ ————— HOT
LIGHT ———————— ■ HEAVY

ORIGIN: Switzerland

TYPICAL INGREDIENTS:
Cheese, boiled potatoes,
pickled veggies, cured meats

SPOTTED BY AMY D.

56 / MEAL

Raclette

/rah-CLET/ Like fondue, raclette is based on melting cheese. It is both the name of the dish, from the word *racler* (to scrape), and the cow's-milk cheese at the center of the meal. A half raclette round is placed in front of a heat source. When the exposed cheese bubbles, it is scraped off onto a plate filled with small boiled potatoes. Pickled gherkins and onions and a plate of cured meats usually accompany the meal. A modern version of the meal uses a tabletop grill to melt slices of cheese for each diner instead of a roaring fireplace.

spotted this

ON:

AT:

WITH:

WANT

TRIED

LOVED

My thoughts

TASTES LIKE:

☆ ☆ ☆ ☆ ☆
FLAVOR

FEELS LIKE:

☆ ☆ ☆ ☆ ☆
TEXTURE

SMELLS LIKE:

☆ ☆ ☆ ☆ ☆
AROMA

LOOKS LIKE:

☆ ☆ ☆ ☆ ☆
APPEARANCE

SOUNDS LIKE:

☆ ☆ ☆ ☆ ☆
NOISE

ADDITIONAL NOTES:

HOW IT MADE ME FEEL

♡ ♡ ♡ ♡ ♡
OVERALL

SWEET	SAVORY
COLD	HOT
LIGHT	HEAVY

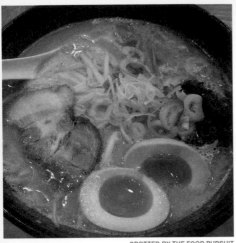

SPOTTED BY THE FOOD PURSUIT

ORIGIN: China, but considered Japanese

TYPICAL INGREDIENTS: Noodles, pork-based broth, toppings

57 / MEAL

Ramen

/RAH-men/ Ramen is a Japanese noodle soup that originated in China. While there are many variations, the broth dictates the flavor, style of noodles, and garnishes. The most common are *shio* or salt, *tonkotsu* or pork bone, *shoyu* or soy sauce, and miso. Almost all of these start with a tonkotsu base unless you can find the rare sesame- or soy-based broths. The shio is a lighter soup with clearer broth and any combination of seafood, vegetables, and meat. Tonkotsu (also known as *hakata*) is a velvety, full-flavored, and cloudy broth. The more common shoyu focuses on soy sauce flavors, while the miso is made with miso and other meat or fish broth. You can often choose from a number of toppings, from roast pork to a soft-boiled egg. *Kuro* ramen (black ramen) is made using black garlic or black miso.

spotted this

ON:

AT:

WITH:

WANT

TRIED

LOVED

My thoughts

TASTES LIKE:

☆ ☆ ☆ ☆ ☆
FLAVOR

FEELS LIKE:

☆ ☆ ☆ ☆ ☆
TEXTURE

SMELLS LIKE:

☆ ☆ ☆ ☆ ☆
AROMA

LOOKS LIKE:

☆ ☆ ☆ ☆ ☆
APPEARANCE

SOUNDS LIKE:

☆ ☆ ☆ ☆ ☆
NOISE

ADDITIONAL NOTES:

HOW IT MADE ME FEEL

♡ ♡ ♡ ♡ ♡
OVERALL

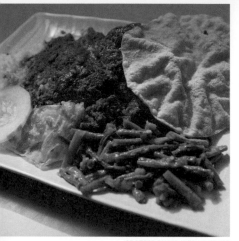

SWEET ──── ▮ ──── SAVORY
COLD ──── ▮ ──── HOT
LIGHT ──── ▮ ──── HEAVY

ORIGIN: Indonesia

TYPICAL INGREDIENTS: Beef, coconut milk, garlic, shallot, lemongrass, chile, spices

SPOTTED BY MOUNTAINCATKING

Rendang

/ren-DAHNG/ Indonesian rendang isn't just a beef curry stew. Slow-cooked beef cubes in spiced coconut milk are step one of the process, but the meat must simmer until the coconut milk is nearly evaporated and turns into brown oil. The meat then fries in the oil while the two are stirred together vigorously. Rendang's final appearance isn't saucy; it looks like a paste. The dish's distinctive flavors come from garlic, shallot, and ginger, as well as lemongrass, chile, turmeric leaves, and galangal. Enjoy rendang with steamed rice or *ketupat*, a compressed rice cake. A wetter variation found in the Netherlands and Malaysia is called *kalio*.

I spotted this

ON:

AT:

WITH:

WANT

TRIED

LOVED

My thoughts

TASTES LIKE:

☆☆☆☆☆
FLAVOR

FEELS LIKE:

☆☆☆☆☆
TEXTURE

SMELLS LIKE:

☆☆☆☆☆
AROMA

LOOKS LIKE:

☆☆☆☆☆
APPEARANCE

SOUNDS LIKE:

☆☆☆☆☆
NOISE

ADDITIONAL NOTES:

HOW IT MADE ME FEEL

♡♡♡♡♡
OVERALL

SWEET ——————▉—— SAVORY
COLD ——————▉—— HOT
LIGHT ——————▉—— HEAVY

ORIGIN: India

TYPICAL INGREDIENTS: Wheat flour, ghee

SPOTTED BY LEONARD ONG (DOR)

59 / SIDE

Roti Prata

/ROH-tee PRAH-thuh/ *Roti* means "flatbread" in most of South Asia.
Paratha is a type of Indian roti made with ghee and sometimes a filling.
When paratha migrated to Malaysia and Singapore, the cooking style
and presentation changed and it became roti prata. When you order it
in Singapore (a.k.a. *roti canai* in Malaysia), the perfect specimen is flaky,
chewy, and leaves you with slightly slick fingers. A mound of doughy
batter is pulled flat on a griddle, and then folded like an envelope again
and again. The finished bread is served with curry for dipping. It can also
be topped with condensed milk. You can find a thinner, bigger version of
paratha in Trinidad and Tobago.

spotted this

ON:

AT:

WITH:

WANT

TRIED

LOVED

My thoughts

TASTES LIKE:

☆☆☆☆☆
FLAVOR

FEELS LIKE:

☆☆☆☆☆
TEXTURE

SMELLS LIKE:

☆☆☆☆☆
AROMA

LOOKS LIKE:

☆☆☆☆☆
APPEARANCE

SOUNDS LIKE:

☆☆☆☆☆
NOISE

ADDITIONAL NOTES:

HOW IT MADE ME FEEL

♡♡♡♡♡
OVERALL

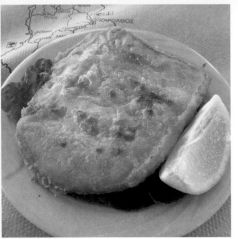

ORIGIN: Greece

TYPICAL INGREDIENTS:
Cheese, flour, lemon, bread

SPOTTED BY P LIOKEL

60 / SIDE

Saganaki

/sah-ga-NAH-key/ There are two styles of saganaki: the traditional Greek small-pan appetizer and the dramatic Americanized flaming cheese. The saganaki of Greece is made with *kasseri*, *halloumi*, or goat feta cheese. It's lightly coated in batter, then dropped into an oiled pan and fried. It's important that the cheese keeps its shape and does not dissolve into a puddle. Once soft and bubbly, the cheese is served with some lemon and a dash of pepper. *Saganaki* can also refer more generally to Greek dishes cooked in a small pan. The cheese version reigns supreme, but saganaki can also include shrimp.

spotted this

ON:

AT:

WITH:

WANT

TRIED

LOVED

My thoughts

TASTES LIKE:

☆☆☆☆☆
FLAVOR

FEELS LIKE:

☆☆☆☆☆
TEXTURE

SMELLS LIKE:

☆☆☆☆☆
AROMA

LOOKS LIKE:

☆☆☆☆☆
APPEARANCE

SOUNDS LIKE:

☆☆☆☆☆
NOISE

ADDITIONAL NOTES:

HOW IT MADE ME FEEL

♡♡♡♡♡
OVERALL

SPOTTED BY MENG HE

ORIGIN: United Kingdom

TYPICAL INGREDIENTS: Hard-boiled egg, sausage, bread crumbs

61 / SNACK

Scotch Egg

/SKAHCH egg/ Pork sausage and egg make a happy combination in the ubiquitous British snack of Scotch eggs. Somewhere in the eighteenth-century United Kingdom, a home cook or hotel chef took a hard-boiled egg, covered it in seasoned pork sausage, rolled it in bread crumbs, and gleefully tossed it into a deep fryer. It may have the traditional hard-boiled yolk or come with a runny center. It can be served hot or cold, dipped into hot mustard or even warm gravy to enjoy. Try the Manchester egg too: It's a pickled egg wrapped in dark-colored blood pudding. Other variations include *vogelnestje* from the Netherlands, *kwek-kwek* in the Philippines, and Brazilian *bolovo*.

spotted this

ON:

AT:

WITH:

WANT

TRIED

LOVED

My thoughts

TASTES LIKE:

☆ ☆ ☆ ☆ ☆
FLAVOR

FEELS LIKE:

☆ ☆ ☆ ☆ ☆
TEXTURE

SMELLS LIKE:

☆ ☆ ☆ ☆ ☆
AROMA

LOOKS LIKE:

☆ ☆ ☆ ☆ ☆
APPEARANCE

SOUNDS LIKE:

☆ ☆ ☆ ☆ ☆
NOISE

ADDITIONAL NOTES:

HOW IT MADE ME FEEL

♡ ♡ ♡ ♡ ♡
OVERALL

SWEET	———■———	SAVORY
COLD	———■———	HOT
LIGHT	———■———	HEAVY

ORIGIN: Tunisia

TYPICAL INGREDIENTS:
Tomato, onion, spices, eggs

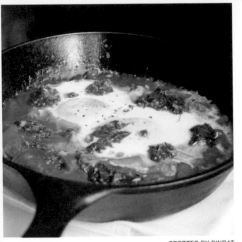

SPOTTED BY PINRAT

62 / MEAL

Shakshouka

/shahk-SHUE-cah/ What about a morning meal for the spice-lover, the tomato fan, the runny yolk expert? The answer is shakshouka: eggs immersed in tomato, onion, and pepper stew scooped up with bits of flatbread. The name of this North African staple means "a mixture" or "shaken." Vegetables are fried with chile, cumin, garlic, and paprika and then an egg is broken on top to soft poach. The finishing touch is a sprinkle of *ras el hanout*, the spice mixture. Try the similarly prepared *huevos rancheros* from Mexico or the Turkish dish *menemen*.

I spotted this

ON:

AT:

WITH:

WANT

TRIED

LOVED

My thoughts

TASTES LIKE:

☆☆☆☆☆
FLAVOR

FEELS LIKE:

☆☆☆☆☆
TEXTURE

SMELLS LIKE:

☆☆☆☆☆
AROMA

LOOKS LIKE:

☆☆☆☆☆
APPEARANCE

SOUNDS LIKE:

☆☆☆☆☆
NOISE

ADDITIONAL NOTES:

HOW IT MADE ME FEEL

♡♡♡♡♡
OVERALL

SWEET	■ SAVORY
COLD	■ HOT
LIGHT	■ HEAVY

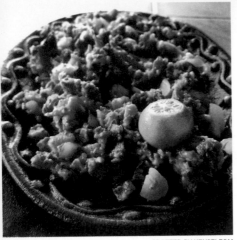

ORIGIN: Philippines

TYPICAL INGREDIENTS:
Pig's head and ears, garlic,
chile peppers, citrus juice,
peppercorns

SPOTTED BY KRYSTLEQM

63 / MEAL

Sizzling Sisig

/SIZ-ling SIS-sig/ The unusual meat source makes this dish pop; it's made
from pig's head and ears. While sisig originated from a much older Filipino
tradition, one woman, Lucia Cunanan, the Sisig Queen, reinvented it dur-
ing the 1970s and popularized it to its present glory. Pig's head and ears
are boiled, then grilled, and finally fried on a hot serving plate. Onions,
garlic, chile, and *calamansi* or lime juice are then mixed in. You can also
try sisig with regular pork. Sizzling sisig may be served with a raw egg
in the middle, pork cracklings (called *chicharrón*), or even chicken livers
thrown in for good measure.

I spotted this

ON:

AT:

WITH:

WANT

TRIED

LOVED

My thoughts

TASTES LIKE:

☆ ☆ ☆ ☆ ☆
FLAVOR

FEELS LIKE:

☆ ☆ ☆ ☆ ☆
TEXTURE

SMELLS LIKE:

☆ ☆ ☆ ☆ ☆
AROMA

LOOKS LIKE:

☆ ☆ ☆ ☆ ☆
APPEARANCE

SOUNDS LIKE:

☆ ☆ ☆ ☆ ☆
NOISE

ADDITIONAL NOTES:

HOW IT MADE ME FEEL

♡ ♡ ♡ ♡ ♡
OVERALL

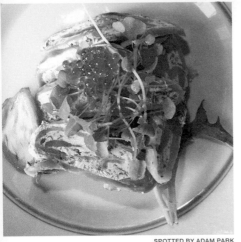

SWEET ———————■——— SAVORY
COLD ———■———————— HOT
LIGHT ————■——————— HEAVY

ORIGIN: Denmark

TYPICAL INGREDIENTS: Rye bread, butter, assorted toppings

Smørrebrød

/SCHMAR-brood/ Calling smørrebrød a Danish open-faced sandwich might make the snack sound dull, but it is anything but boring. It is a common dish that is served morning, noon, and night. The base is dense, thinly sliced sourdough rye bread smeared with butter. Then comes a buffet of toppings, commonly including mayonnaise, pickled herring (plain or curried), cured salmon and salmon roe, cucumber slices, tomato, sliced deli meat, *leverpostej* (a liver paste), and sliced red onion. Each person makes his or her own serving, so no two sandwiches are alike.

I spotted this

ON:

AT:

WITH:

WANT

TRIED

LOVED

My thoughts

TASTES LIKE:

☆☆☆☆☆
FLAVOR

FEELS LIKE:

☆☆☆☆☆
TEXTURE

SMELLS LIKE:

☆☆☆☆☆
AROMA

LOOKS LIKE:

☆☆☆☆☆
APPEARANCE

SOUNDS LIKE:

☆☆☆☆☆
NOISE

ADDITIONAL NOTES:

HOW IT MADE ME FEEL

♡♡♡♡♡
OVERALL

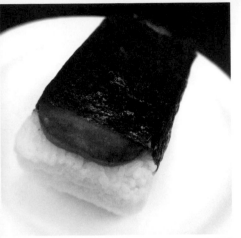

SWEET	———■———	SAVORY
COLD	——■——	HOT
LIGHT	———■——	HEAVY

ORIGIN: United States of America, Hawaii

TYPICAL INGREDIENTS: SPAM, rice, nori, soy sauce

SPOTTED BY S. LUKE

65 / SNACK

SPAM Musubi

/spam moo-SUE-bee/ Hawaiians consume more SPAM than anyone else in the United States. Why? It might be because of this iconic dish. SPAM *musubi* is a simple and handy snack; it's the perfect combination of Asian and American ingredients. Teriyaki- or soy-glazed SPAM is layered onto a block of sticky rice and wrapped with *nori* (a crisp sheet of dried, flat seaweed). Sometimes *furikake* seasoning (made with fish bits, sesame seeds, seaweed, sugar, and salt) is added to the rice before wrapping. The presentation is based on Japanese *omusubi*. SPAM musubi can be made with or without the rice seasoning or the addition of a scrambled egg. Other musubi might substitute fried shrimp or a breaded pork cutlet.

I spotted this

ON:

AT:

WITH:

WANT

TRIED

LOVED

My thoughts

TASTES LIKE:

☆ ☆ ☆ ☆ ☆
FLAVOR

FEELS LIKE:

☆ ☆ ☆ ☆ ☆
TEXTURE

SMELLS LIKE:

☆ ☆ ☆ ☆ ☆
AROMA

LOOKS LIKE:

☆ ☆ ☆ ☆ ☆
APPEARANCE

SOUNDS LIKE:

☆ ☆ ☆ ☆ ☆
NOISE

ADDITIONAL NOTES:

HOW IT MADE ME FEEL

♡ ♡ ♡ ♡ ♡
OVERALL

SWEET ──────■──── SAVORY
COLD ■──────────── HOT
LIGHT ───■──────── HEAVY

ORIGIN: France

TYPICAL INGREDIENTS: Beef, egg yolk, spices

SPOTTED BY FLORE AND WENDELL ADDISON

Steak Tartare

/STAYK tar-TAR/ Travel in Europe—France particularly—and you'll notice that steak tartare is a staple of the European diet. Originally called steak à l'Americaine, it is a dish made of minced raw beef (or horse) served with capers, diced onion, gherkins, salt, and pepper. Sometimes it is served with a raw egg yolk on top to be mixed in. Make sure to sample tartare at a restaurant where the meat is served within an hour of hand chopping. You should also receive something to accompany each bite, like toast or potato chips. The term *tartare* is also used to describe other raw meat dishes, such as tuna tartare.

spotted this

ON:

AT:

WITH:

WANT

TRIED

LOVED

My thoughts

TASTES LIKE:

☆ ☆ ☆ ☆ ☆
FLAVOR

FEELS LIKE:

☆ ☆ ☆ ☆ ☆
TEXTURE

SMELLS LIKE:

☆ ☆ ☆ ☆ ☆
AROMA

LOOKS LIKE:

☆ ☆ ☆ ☆ ☆
APPEARANCE

SOUNDS LIKE:

☆ ☆ ☆ ☆ ☆
NOISE

ADDITIONAL NOTES:

HOW IT MADE ME FEEL

♡ ♡ ♡ ♡ ♡
OVERALL

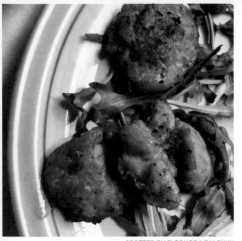

SWEET ——————————■ SAVORY

COLD ——————————■—— HOT

LIGHT ————————■———— HEAVY

ORIGIN: Unrecorded

TYPICAL INGREDIENTS: Calf and lamb thymus and pancreas glands, butter, bread crumbs

SPOTTED BY ELEONORA BALDWIN

67 / SIDE

Sweetbreads

/SWEET-breads/ Sweetbreads or *ris* are the culinary names for calf and lamb glands, mainly the thymus and pancreas. The term "bread" may come from the Old English word *brede* (roasted meat). Sweetbread meat is supposed to be juicier, textured, and more subtly flavored than muscle. The French prepare sweetbreads by soaking the glands, poaching them in milk, and sautéeing them in butter. Sweetbreads may also be breaded and fried. There are several other gland and organ parts, collectively referred to as offal, that are similarly used in cooking around the world. These include the heart, tripe, intestines, stomach, cheek, ear, tongue, throat, and testicles.

spotted this

ON:

AT:

WITH:

WANT

TRIED

LOVED

My thoughts

TASTES LIKE:

☆☆☆☆☆
FLAVOR

FEELS LIKE:

☆☆☆☆☆
TEXTURE

SMELLS LIKE:

☆☆☆☆☆
AROMA

LOOKS LIKE:

☆☆☆☆☆
APPEARANCE

SOUNDS LIKE:

☆☆☆☆☆
NOISE

ADDITIONAL NOTES:

HOW IT MADE ME FEEL

♡♡♡♡♡
OVERALL

SWEET ─────■───── SAVORY
COLD ─────■───── HOT
LIGHT ─────■───── HEAVY

ORIGIN: Morocco
TYPICAL INGREDIENTS:
Meat, vegetables, spices

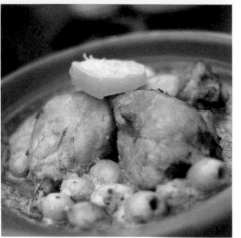

SPOTTED BY DANICHRO

68 / MEAL

Tagine

/tuh-ZJEAN/ A *tagine* is both effective cookware and a culinary tradition that hails from Morocco. Made of glazed earthenware, the cookware's pointed lid collects and returns condensation and steam to the bottom dish, which makes it perfect for long-simmering stews and braising. The typical recipe exemplifies savory mixed with sweet. Lamb might accompany olives, prunes, dates, and preserved lemons, with spices like cumin, cinnamon, ginger, paprika, highly prized saffron, and the spice mix *ras el hanout*. You might also find *koftas*, or meatballs, cooked in a tagine. Seafood, beef, and chicken are also used in tagine dishes. Don't confuse it with the Tunisian *tajine*, which is like a frittata.

I spotted this

ON:

AT:

WITH:

WANT

TRIED

LOVED

My thoughts

TASTES LIKE:

☆ ☆ ☆ ☆ ☆

FLAVOR

FEELS LIKE:

☆ ☆ ☆ ☆ ☆

TEXTURE

SMELLS LIKE:

☆ ☆ ☆ ☆ ☆

AROMA

LOOKS LIKE:

☆ ☆ ☆ ☆ ☆

APPEARANCE

SOUNDS LIKE:

☆ ☆ ☆ ☆ ☆

NOISE

ADDITIONAL NOTES:

HOW IT MADE ME FEEL

♡ ♡ ♡ ♡ ♡

OVERALL

SWEET	—■———————	SAVORY
COLD	—————■———	HOT
LIGHT	———■—————	HEAVY

ORIGIN: Japan

TYPICAL INGREDIENTS: Batter, assorted fillings

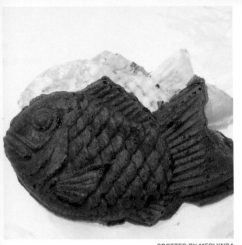

SPOTTED BY MERLYNDA

69 / DESSERT
Taiyaki

/TIE-yah-key/ You'll find taiyaki (or *bungeoppang* as it is known in Korea) across Japan impersonating the majestic sea bream. But taiyaki is not fishy or savory; it's sweet. A fish-shaped taiyaki mold is filled with waffle- or pancake-like batter. A dollop of filling is added and covered in more batter. The vendor flips the mold's lid closed to complete the shape and cook it. The filling is usually red bean paste, but it could also be a custard or chocolate. The taiyaki should be firm on the outside, oozy inside, and accompanied by a cold, wintery day and a cup of green tea.

spotted this

ON:

AT:

WITH:

WANT

TRIED

LOVED

My thoughts

TASTES LIKE:

☆☆☆☆☆
FLAVOR

FEELS LIKE:

☆☆☆☆☆
TEXTURE

SMELLS LIKE:

☆☆☆☆☆
AROMA

LOOKS LIKE:

☆☆☆☆☆
APPEARANCE

SOUNDS LIKE:

☆☆☆☆☆
NOISE

ADDITIONAL NOTES:

HOW IT MADE ME FEEL

♡♡♡♡♡
OVERALL

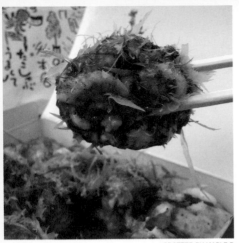

ORIGIN: Japan

TYPICAL INGREDIENTS: Wheat flour batter, octopus, green onion

SPOTTED BY MAPLE.B

70 / SNACK

Takoyaki

/tah-ko-YAH-key/ *Takoyaki* means "octopus, fried." To create this dish, pancake-like batter is poured into a special pan and a piece of octopus is dropped into each rounded well of batter. Then a large toothpick-like utensil is used to rotate each spherical pancake ninety degrees, again and again. Takoyaki is done once each perfectly round specimen is cooked all the way through. The balls are brushed with takoyaki sauce (a sweet and tangy Worcestershire-like sauce), then sprinkled with a variety of condiments like mayonnaise, green onions, and dried bonito. Takoyaki can be prepared with other ingredients, like cheese and meat. You can also find giant takoyaki the size of softballs!

I spotted this

ON:

AT:

WITH:

WANT

TRIED

LOVED

My thoughts

TASTES LIKE:

☆☆☆☆☆
FLAVOR

FEELS LIKE:

☆☆☆☆☆
TEXTURE

SMELLS LIKE:

☆☆☆☆☆
AROMA

LOOKS LIKE:

☆☆☆☆☆
APPEARANCE

SOUNDS LIKE:

☆☆☆☆☆
NOISE

ADDITIONAL NOTES:

HOW IT MADE ME FEEL

♡♡♡♡♡
OVERALL

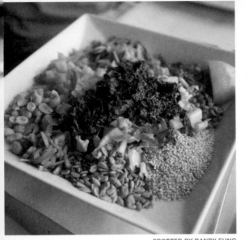

ORIGIN: Burma

TYPICAL INGREDIENTS:
Fermented tea leaves, a bevy
of toppings

SPOTTED BY RANDY FUNG

71 / SIDE

Tea Leaf Salad

/tee leef SAL-ad/ If you've never had it before, tea salad may not sound
appetizing. Unique to Burma (Myanmar), fermented tea leaf salad is
generally reserved for special occasions, but may also be found on tea
shop menus. Part of the fun is how the salad (*laphet thoke* in Burmese)
is served. The presentation looks like a vegetable platter spread, with
the tea leaves in the middle, surrounded by ginger slices, peas, fried
peanuts, fried garlic, dried shrimp, fried rice bits, and toasted sesame.
The ingredients are tossed together before it's ready to eat. Despite the
name, tea leaf salad may or may not include lettuce. Sometimes the salad
is presented premixed.

I spotted this

ON:

AT:

WITH:

WANT

TRIED

LOVED

My thoughts

TASTES LIKE:

☆☆☆☆☆
FLAVOR

FEELS LIKE:

☆☆☆☆☆
TEXTURE

SMELLS LIKE:

☆☆☆☆☆
AROMA

LOOKS LIKE:

☆☆☆☆☆
APPEARANCE

SOUNDS LIKE:

☆☆☆☆☆
NOISE

ADDITIONAL NOTES:

HOW IT MADE ME FEEL

♡♡♡♡♡
OVERALL

SWEET	———————	■ SAVORY
COLD	■———————	HOT
LIGHT	———■———	HEAVY

ORIGIN: Spain

TYPICAL INGREDIENTS:
Potato, egg, onion, olive oil

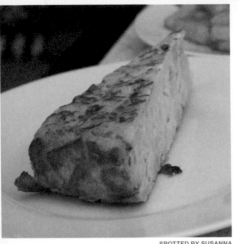

SPOTTED BY SUSANNA

72 / SNACK

Tortilla de Patatas

/tore-TEE-ya day pah-TAH-tahs/ This snack is a Spanish bar staple that you'll find among other savory pinchos—Spanish bar food. It is not like a Mexican tortilla flatbread, but more the bubbly texture of a frittata. It is almost always made with potatoes, eggs, and onions, but countless variations exist. In bars, slices of tortilla de patatas are often served between bread (as *bocadillo*). It may also come with a side of *alioli* (garlic mayonnaise) or tomato sauce. Other ingredients like chorizo, jamón, and peppers might be added. The *tortilla paisana* contains red peppers and peas. Most people outside of Spain know this dish as Tortilla Española.

spotted this

ON:

AT:

WITH:

WANT

TRIED

LOVED

My thoughts

TASTES LIKE:

☆ ☆ ☆ ☆ ☆
FLAVOR

FEELS LIKE:

☆ ☆ ☆ ☆ ☆
TEXTURE

SMELLS LIKE:

☆ ☆ ☆ ☆ ☆
AROMA

LOOKS LIKE:

☆ ☆ ☆ ☆ ☆
APPEARANCE

SOUNDS LIKE:

☆ ☆ ☆ ☆ ☆
NOISE

ADDITIONAL NOTES:

HOW IT MADE ME FEEL

♡ ♡ ♡ ♡ ♡
OVERALL

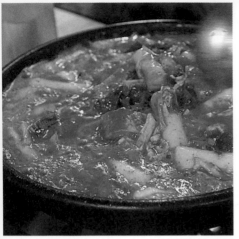

SPOTTED BY JEANNE

SWEET	━━━	▮	SAVORY
COLD	━━━	▮	HOT
LIGHT	━━━	▮	HEAVY

ORIGIN: Korea

TYPICAL INGREDIENTS: Rice sticks, chili paste, fish cakes, green onions

73 / SNACK

Tteokbokki

/dtah-POK-key/ Tteokbokki (also spelled *deokbokki*) descended from the royal courts into street-corner stalls. The original version of the dish, *tteok jjim*, wasn't spicy and was served only to royalty. Now it is happily served to anyone who stumbles upon a *pojangmacha* (vendor) on the streets of Seoul. You can't miss it. The *tteok* (tube-shaped rice sticks) float in bright-red sauce created from a mixture of fish broth, chili paste, cabbage, and fish cake slices. Sliced green onions or sesame seeds add the finishing touch. Sometimes tteokbokki includes both rice cakes and ramen noodles. It can also include dumplings, hard-boiled eggs, and sautéed meat.

I spotted this

ON:	AT:	WITH:	
			WANT
			TRIED
			LOVED

My thoughts

TASTES LIKE: ☆ ☆ ☆ ☆ ☆
FLAVOR

FEELS LIKE: ☆ ☆ ☆ ☆ ☆
TEXTURE

SMELLS LIKE: ☆ ☆ ☆ ☆ ☆
AROMA

LOOKS LIKE: ☆ ☆ ☆ ☆ ☆
APPEARANCE

SOUNDS LIKE: ☆ ☆ ☆ ☆ ☆
NOISE

ADDITIONAL NOTES:

HOW IT MADE ME FEEL

♡ ♡ ♡ ♡ ♡
OVERALL

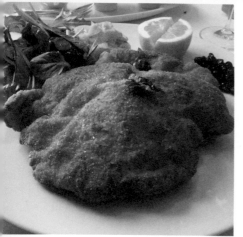

ORIGIN: Austria

TYPICAL INGREDIENTS: Veal, pork, bread crumbs

SPOTTED BY SUSE8600

Wiener Schnitzel

/VEE-ner SCHNIT-tsel/ The fried bliss that is called *wiener schnitzel* hails from Austria, where it is the national dish. Properly made from butterflied veal, the cutlet is breaded and fried to a golden-brown crisp. It's often served with a lemon wedge to add a tangy flavor. Although it can be made using pork and chicken, in Austria, restaurants are legally obligated to use veal. Enjoy schnitzel with the traditional boiled, buttered, and parsleyed potatoes and a nice liter of beer. *Jägerschnitzel* indicates the addition of mushroom gravy, while *zigeunerschnitzel* features a bell pepper sauce. Schnitzel is sometimes casually served in a cold sandwich.

spotted this

ON:

AT:

WITH:

WANT

TRIED

LOVED

My thoughts

TASTES LIKE:

☆ ☆ ☆ ☆ ☆
FLAVOR

FEELS LIKE:

☆ ☆ ☆ ☆ ☆
TEXTURE

SMELLS LIKE:

☆ ☆ ☆ ☆ ☆
AROMA

LOOKS LIKE:

☆ ☆ ☆ ☆ ☆
APPEARANCE

SOUNDS LIKE:

☆ ☆ ☆ ☆ ☆
NOISE

ADDITIONAL NOTES:

HOW IT MADE ME FEEL

♡ ♡ ♡ ♡ ♡
OVERALL

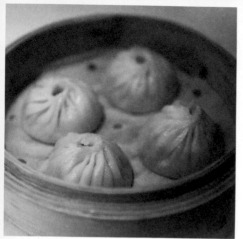

SPOTTED BY PANPANSANG

75 / SIDE

Xiao Long Bao

/shau long BAU/ *Xiao long bao*, sometimes called "soup dumplings," are a kind of steamed, filled Chinese bun. They are different from baozi, as they are made of a tender, translucent dough. Like some baozi, they are usually pinched closed at the top. Xiao long bao are often made with fatty pieces of pork, soy sauce, ginger, scallions, sugar, and sesame oil. The "soup-filled" versions are made with aspic that melts during steaming. Gently lift these into your spoon without breaking the skin, splash on a little vinegar, and nibble off the top. Suck the soup through the top, or pop it whole into your mouth. Xiao long bao can also be made with seafood or other types of meat.

spotted this

ON:

AT:

WITH:

WANT

TRIED

LOVED

My thoughts

TASTES LIKE:

☆☆☆☆☆
FLAVOR

FEELS LIKE:

☆☆☆☆☆
TEXTURE

SMELLS LIKE:

☆☆☆☆☆
AROMA

LOOKS LIKE:

☆☆☆☆☆
APPEARANCE

SOUNDS LIKE:

☆☆☆☆☆
NOISE

ADDITIONAL NOTES:

HOW IT MADE ME FEEL

♡♡♡♡♡
OVERALL

Notes

Notes

DATE DUE

JUL - - 2014

Acknowledgments

We are thankful to the people who enabled us to transform a book idea into an app idea and back again: Our team (Ted Grubb, Soraya Darabi, Seth Andrzejewski, Marc Powell, Fiona Tang, Amy Cao, Ben Bloch, Kim Ahlström, Bob Penrod, Shelly Roche, Chris Connolly, Pablo Delgado, Mohammed Jisrawi, Matt Jarjoura, Aish Fenton, and April Walters), our families (especially Alexa's brother-in-law Daniel Andrzejewski for introducing her to okonomiyaki), our investors, our ambassadors, and our community. Thanks, too, to our OpenTable family for continuing to support Foodspotting and this book.

April V. Walters, would like to thank her husband, Cameron Walters, for his support. She would also like to thank her friends, family, and co-workers for their enthusiasm, especially Alexa Andrzejewski, Juliette Melton, Aaron and Nicola Jacks, Sharon and Ian McKellar, Adam Zolot, and Jason Angeles.